BOTANICAL WONDERLAND

A Blissful Coloring Retreat

RACHEL REINERT

Get Creative 6

An imprint of
Mixed Media Resources
New York

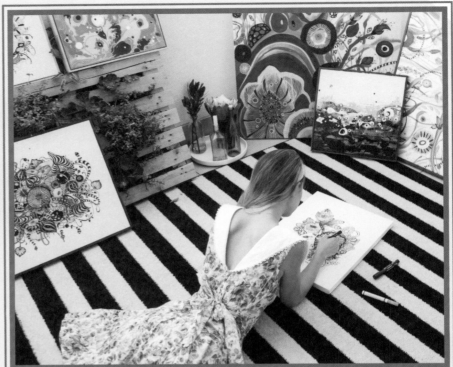
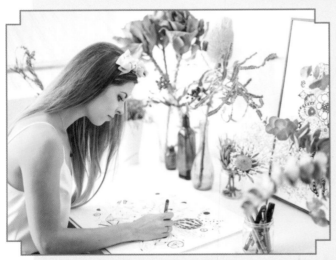
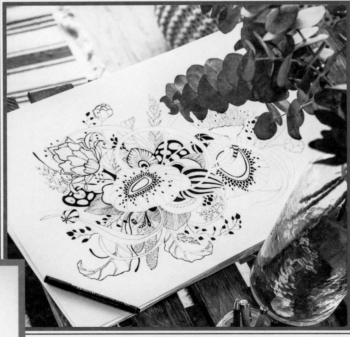
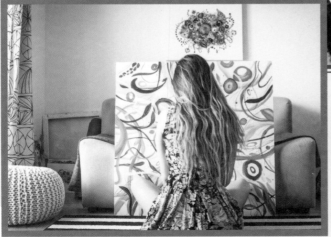
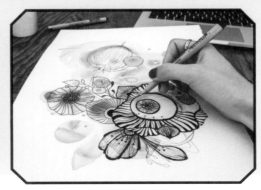

INTRODUCTION

The outdoors are magical to me. I imagine botanicals within playful wonderlands, mysteriously intertwining lines outside of reality. Being taught to paint realistically throughout art school and staying inside the lines always felt counterintuitive. Pressure to perfectly emulate the world wasn't my solution, but I still loved art. Splashing acrylic on a fresh canvas felt right.

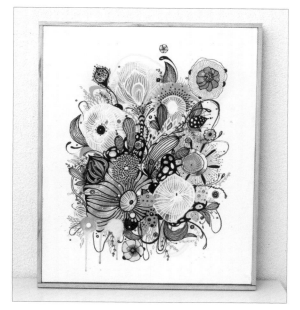

Freelancing, teaching, and traveling have continued to shape my pieces. I've always been in awe of the delicate beauty that Earth offers, from the prehistoric banksia flowers of Australia, to the ocean's flowing undersea gardens and the ornate arrangements of California's desert succulents. The biomorphic artwork in this collection has been inspired by living in Australia for two years, surrounded by dynamic flora and fauna that I had never experienced before coming here.

The drawings in this book are printed on one page each so that you can remove them for display or mixed media experimentation. And as a bonus, I've included one full-color, signed print to use for inspiration or to display. Each hand-drawn illustration invites you to bring it to life through your own imagination. I recommend using Prismacolor colored pencils for the best results. To make the drawings pop, try using an analogous color scheme such as warm or cool tones. In my paintings, I love working with similar colors and then adding an unusual hue to enliven the dreamscape. Start with three to four colors and work from the lightest pencil to the darkest as you blend. Keep your drawing utensils sharpened and let creativity guide you! Just because there are lines doesn't mean you have to stay inside of them.

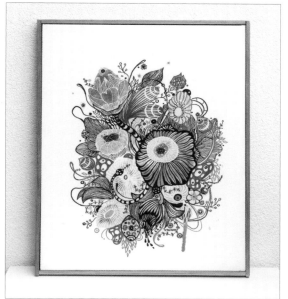

In this collection, I drew what I imagined. Similarly, I invite you to be confident in coloring in any way you desire—whether it be inside or outside the lines. My ultimate hope is that you find this book full of inspiring daydreams and allow yourself to be caught up in an imaginary wonderland.

☀ Bring life into a black and white world.
—RACHEL REINERT

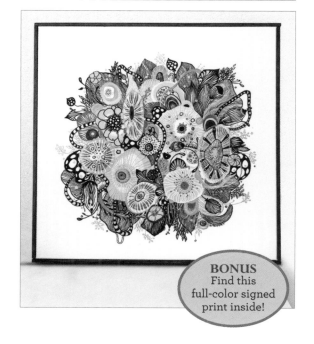

BONUS
Find this full-color signed print inside!

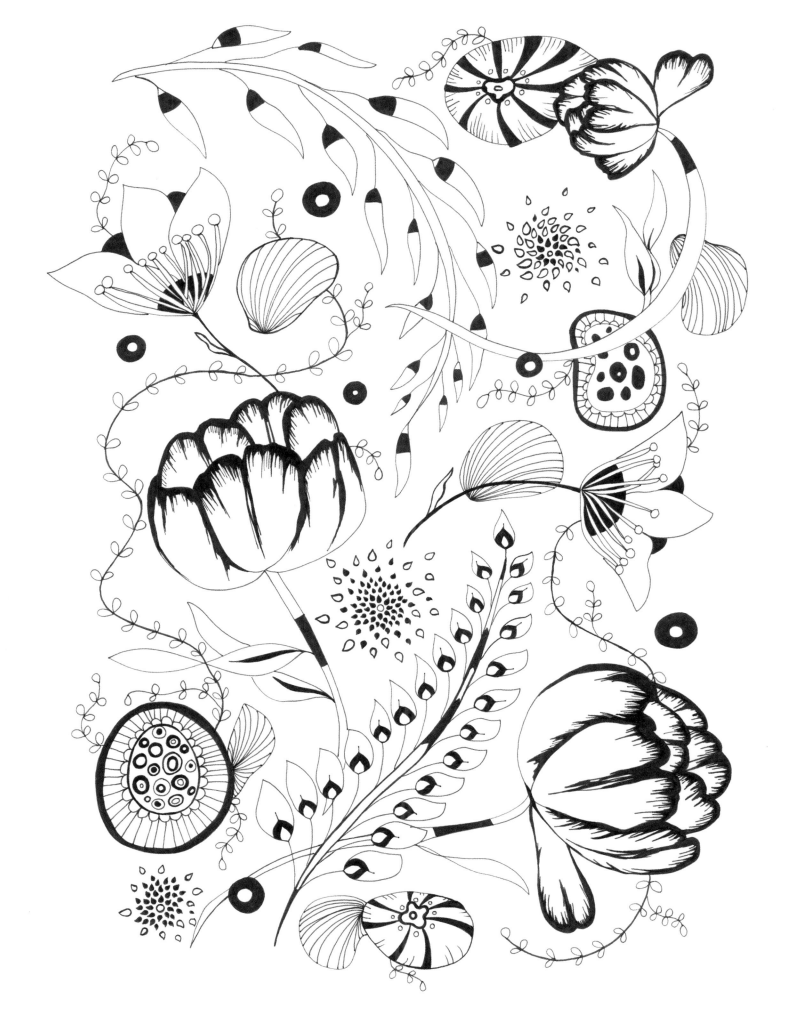

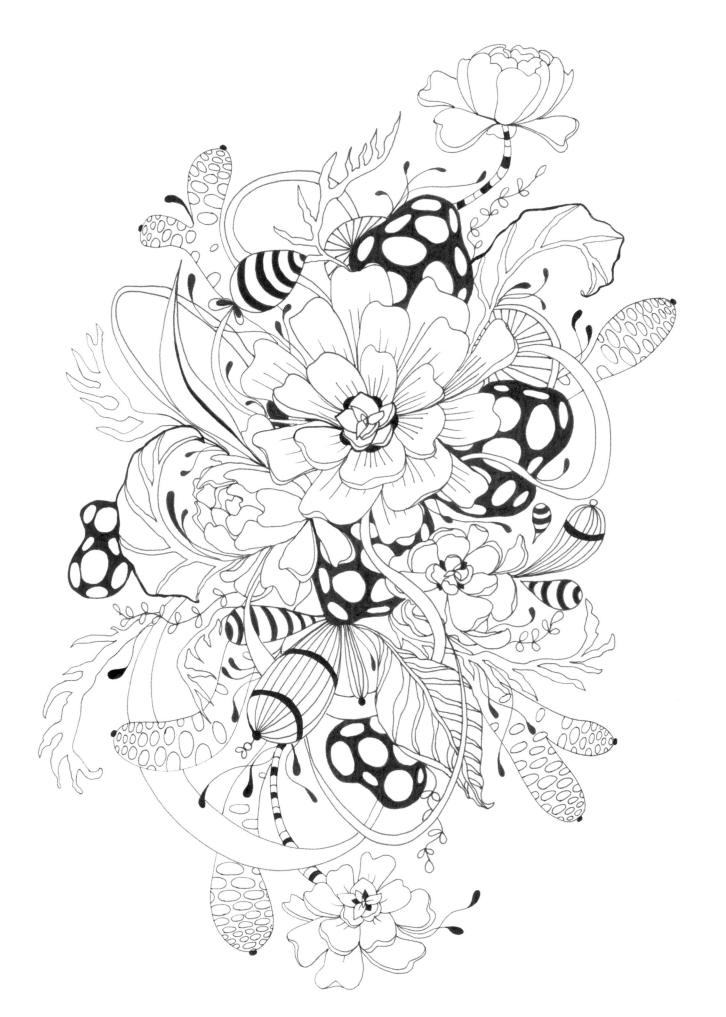

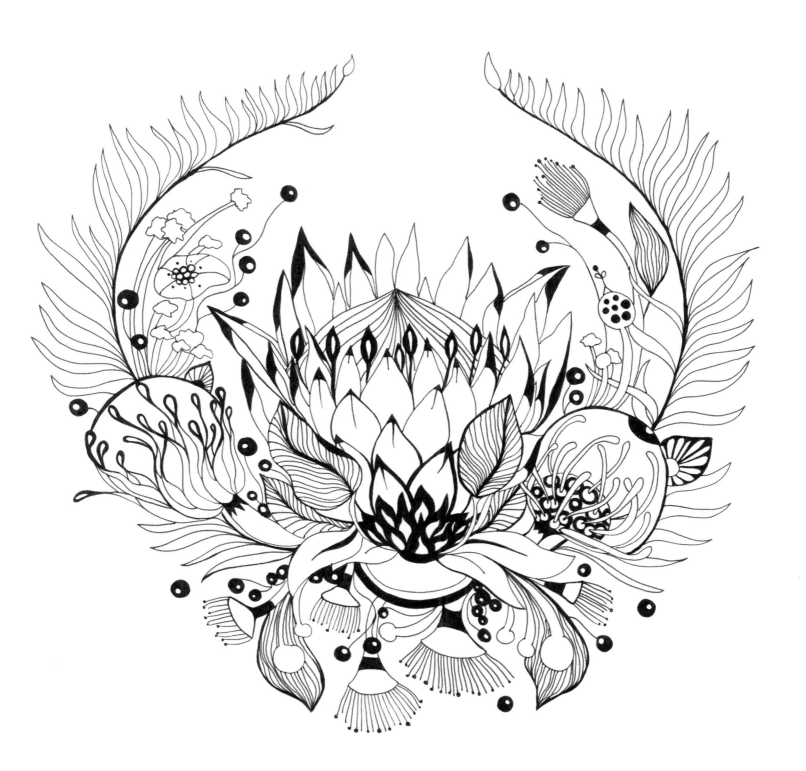

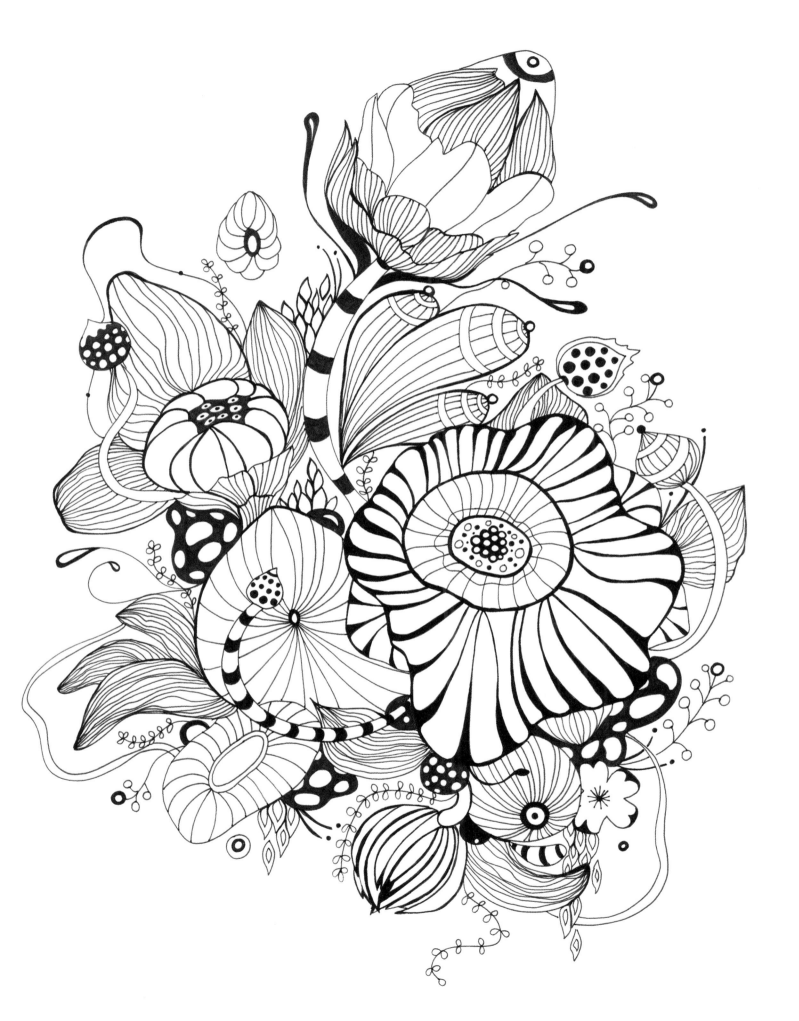

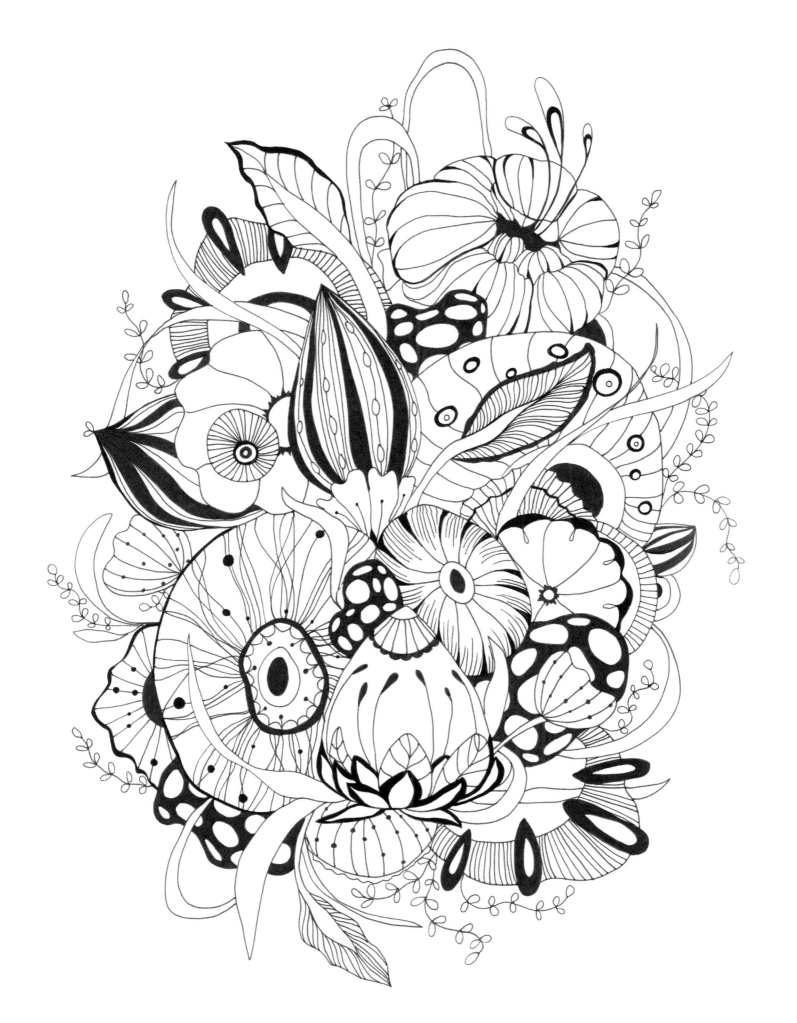

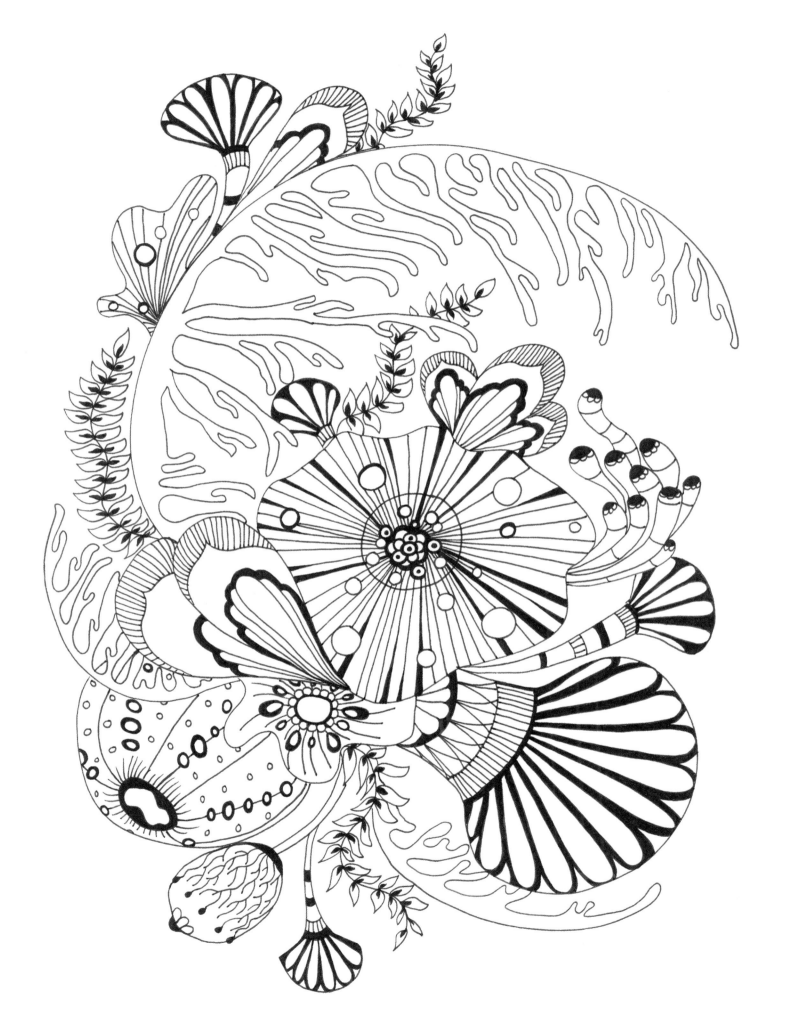

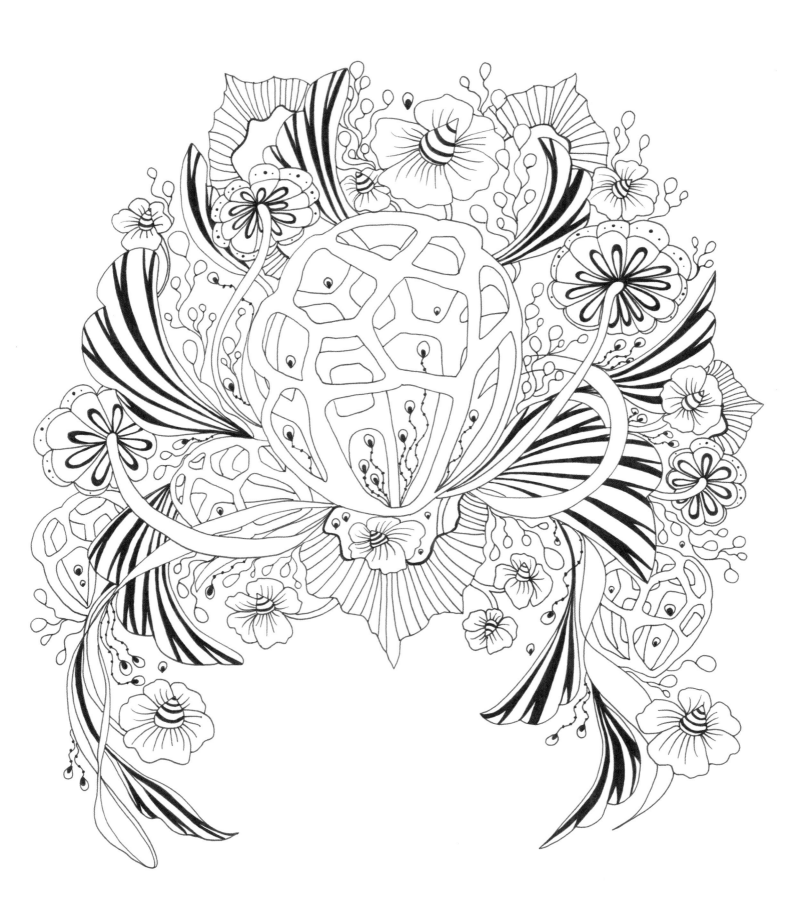

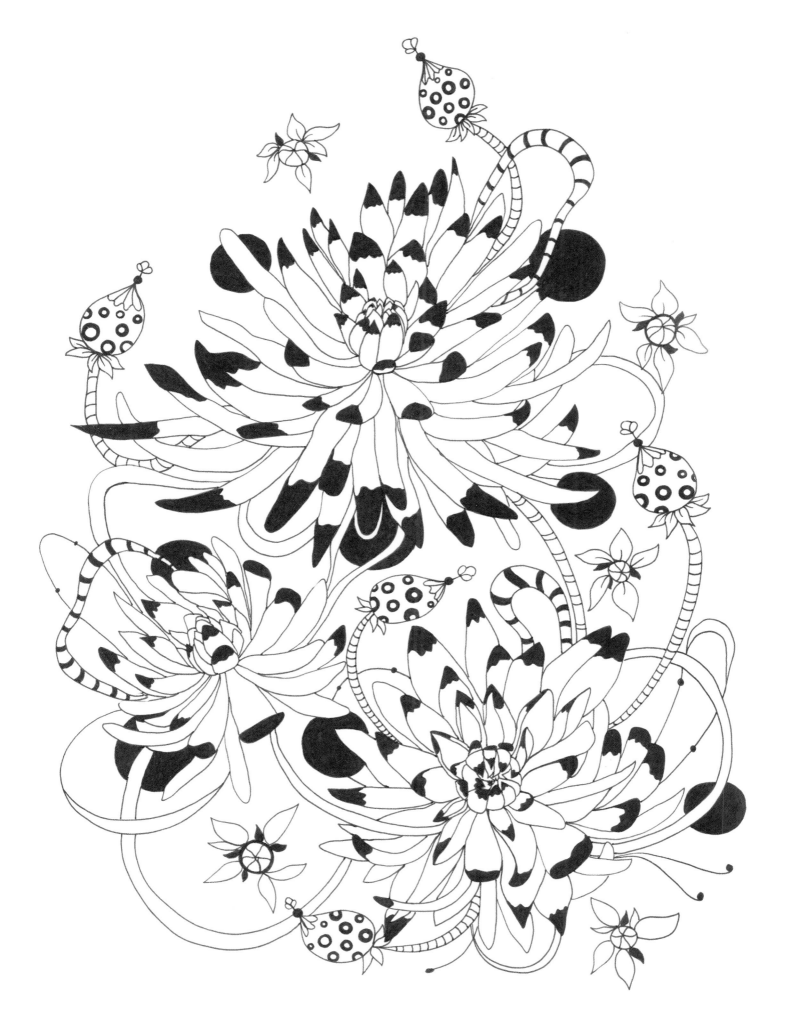

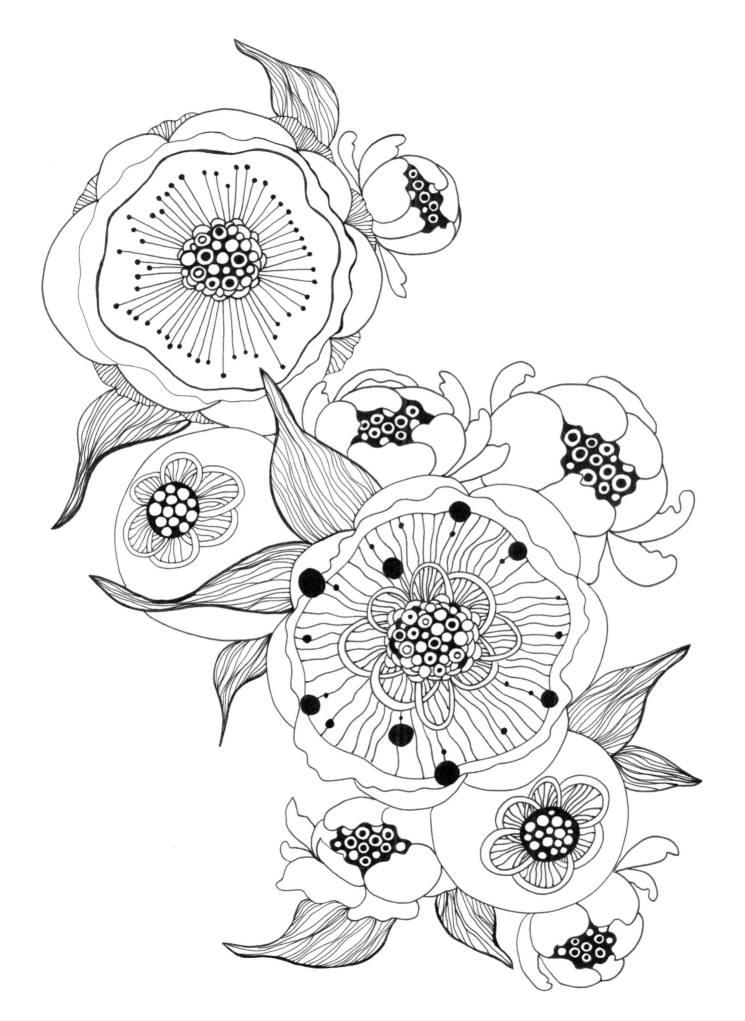

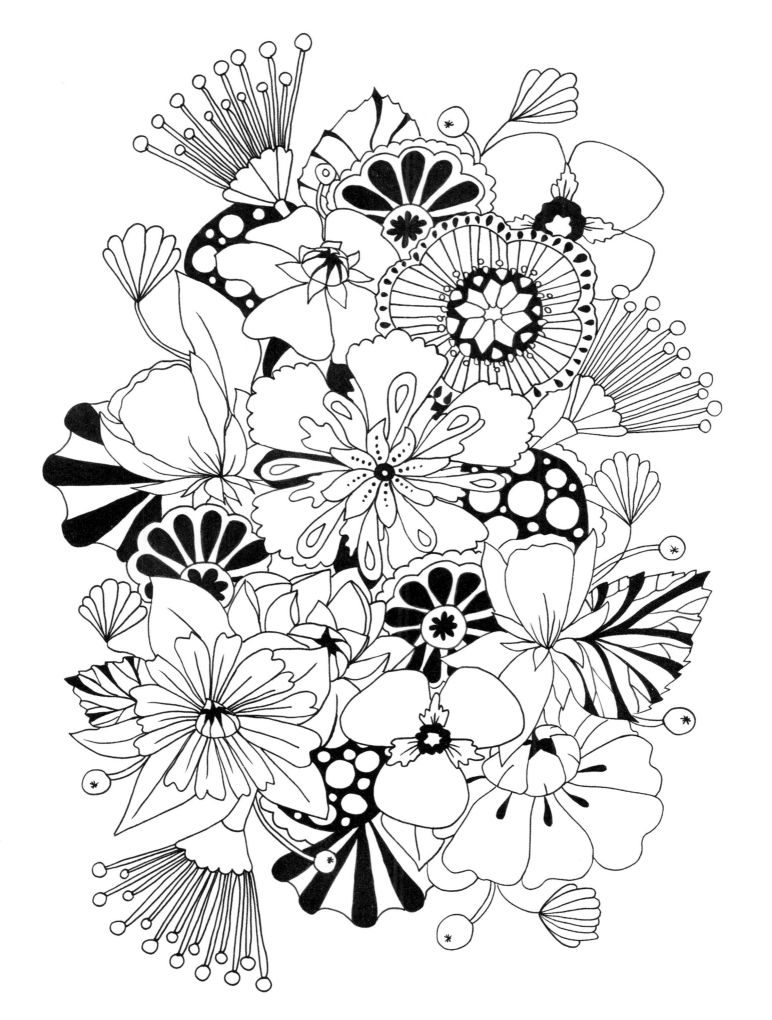

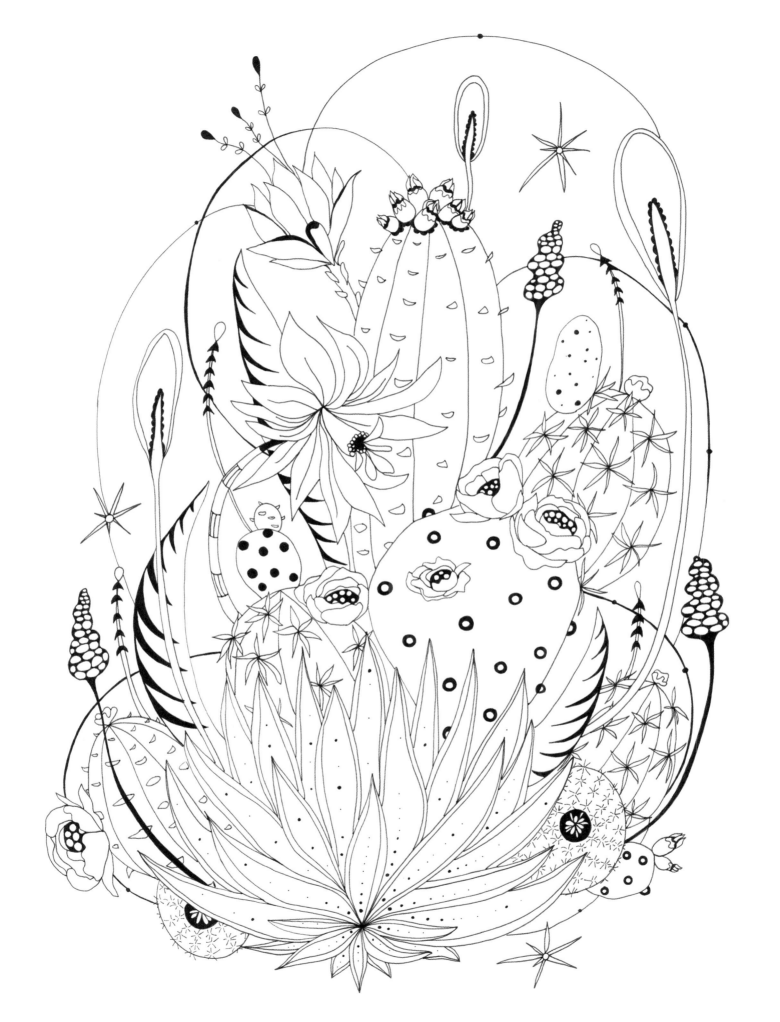

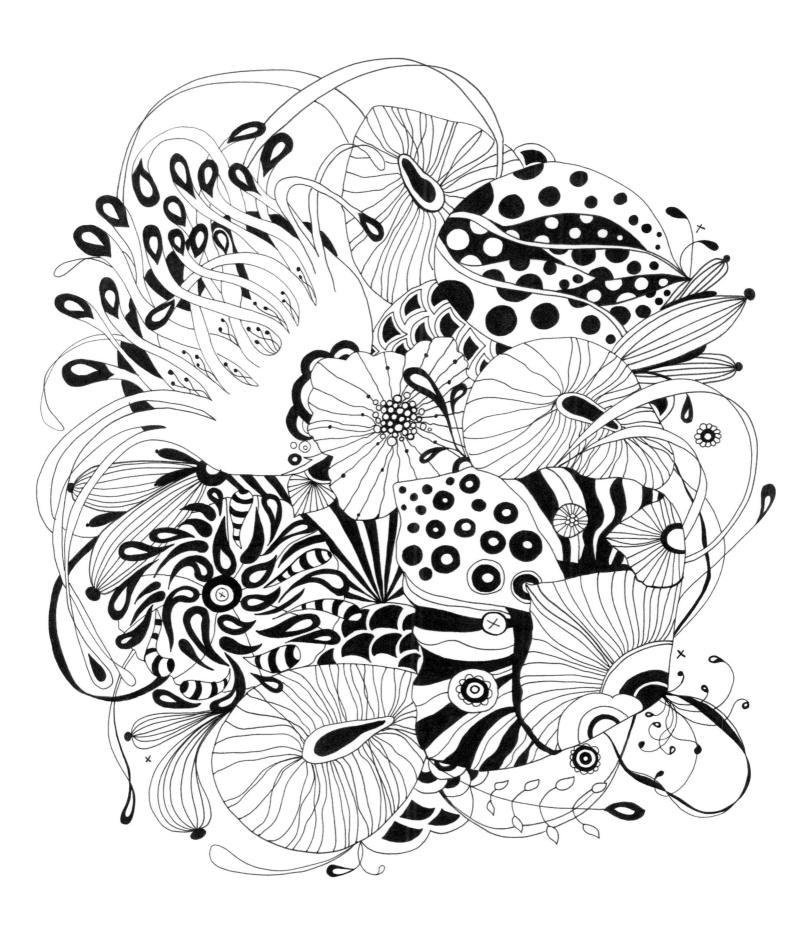

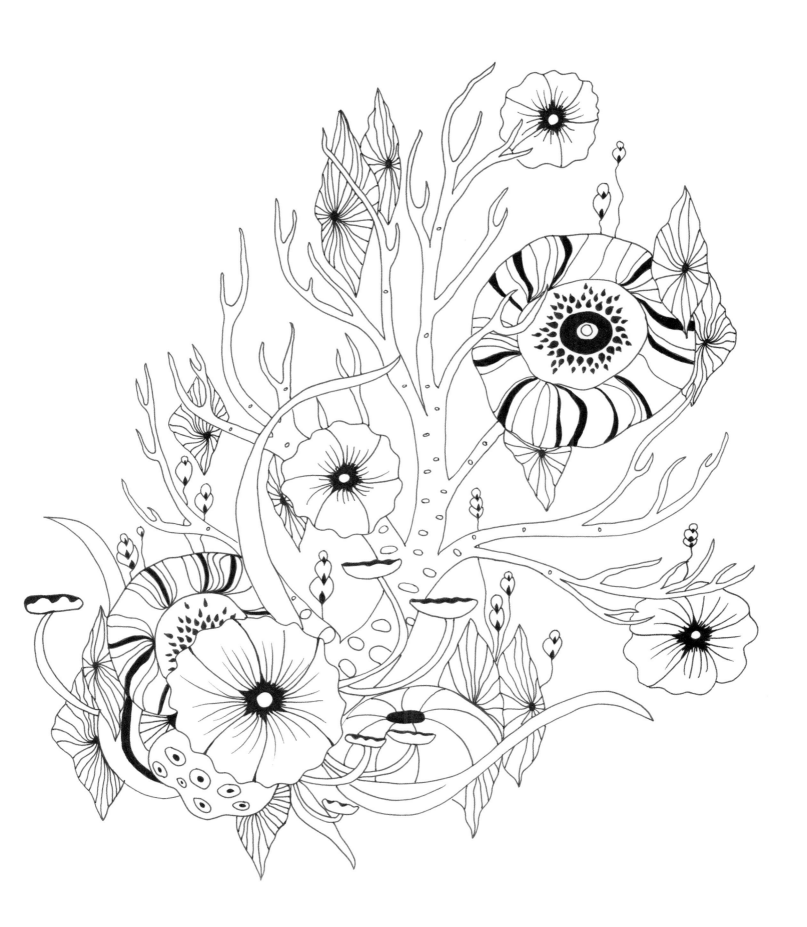

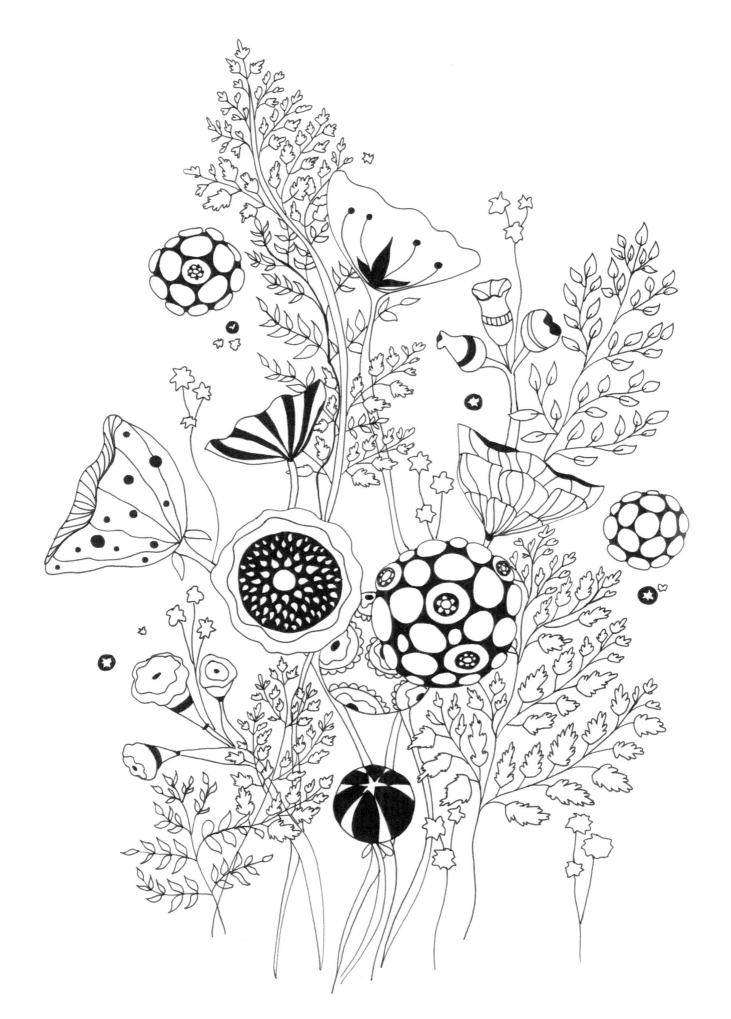

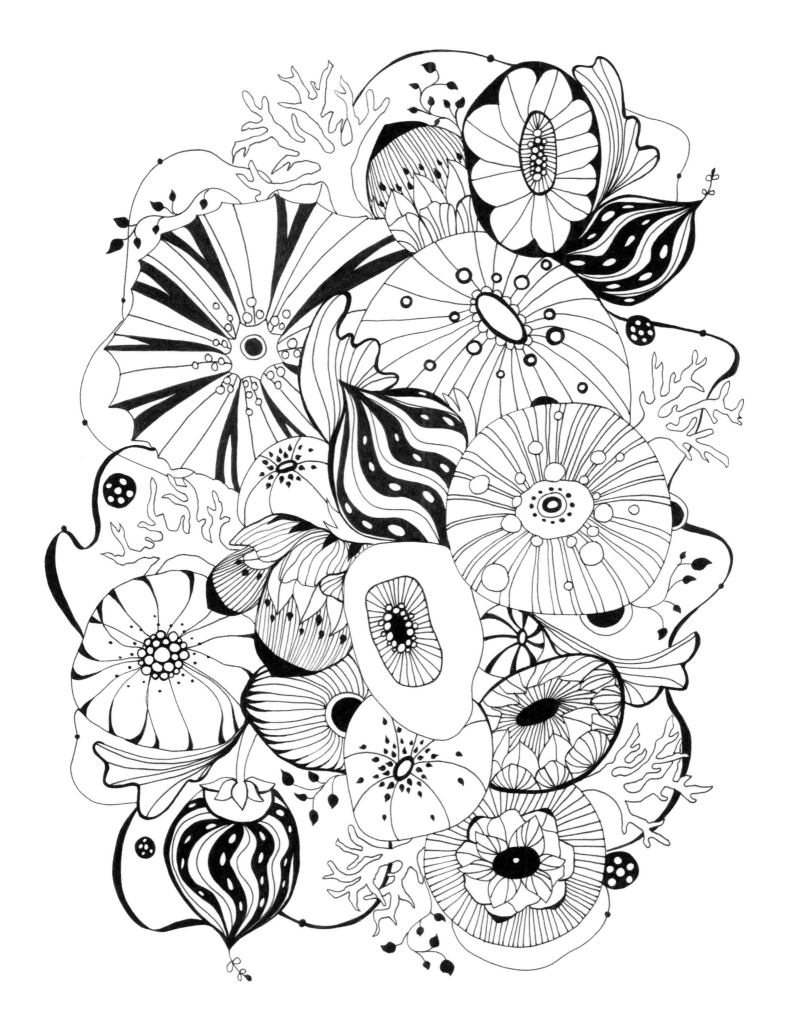

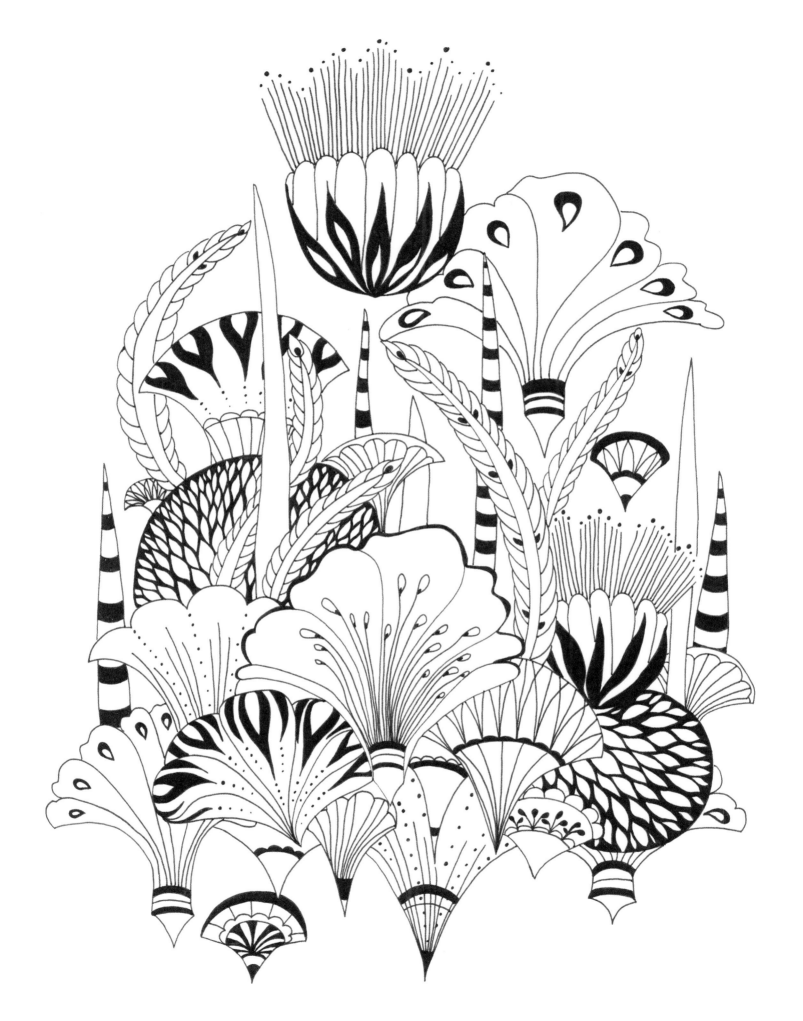

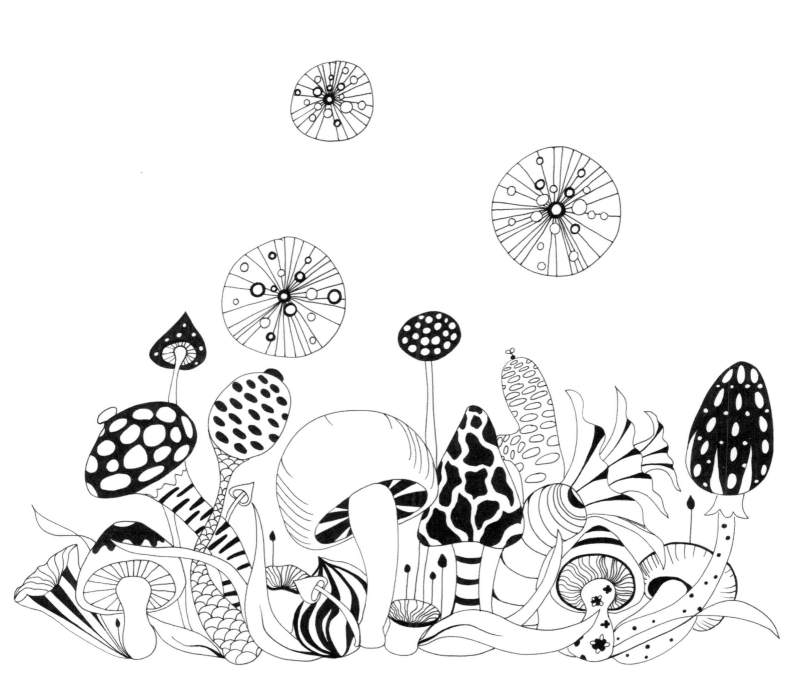

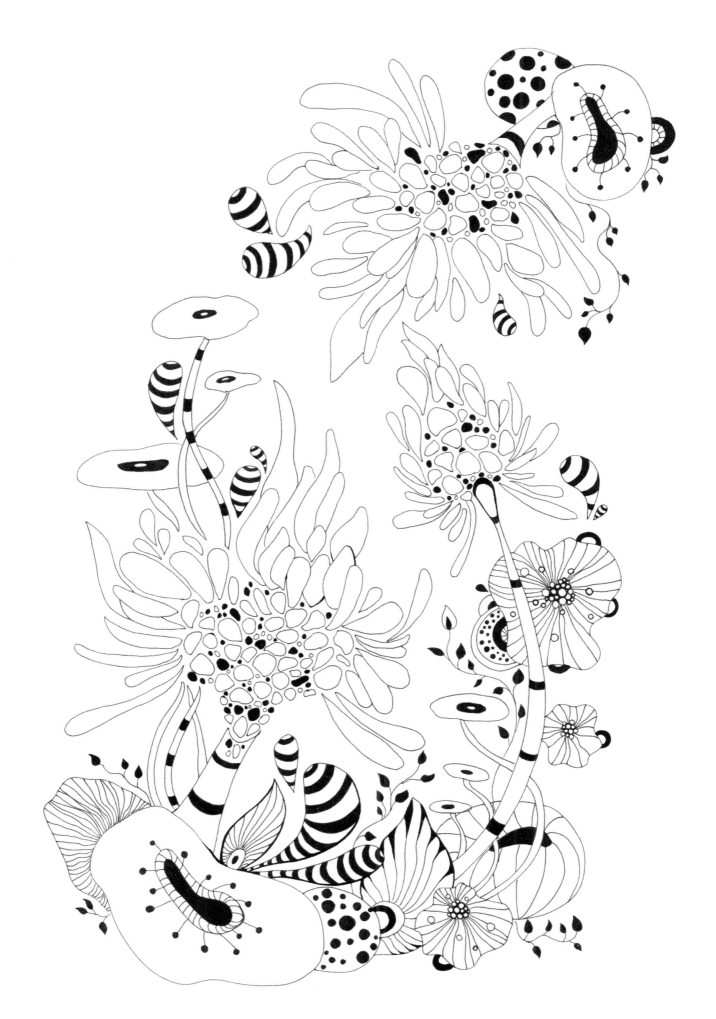

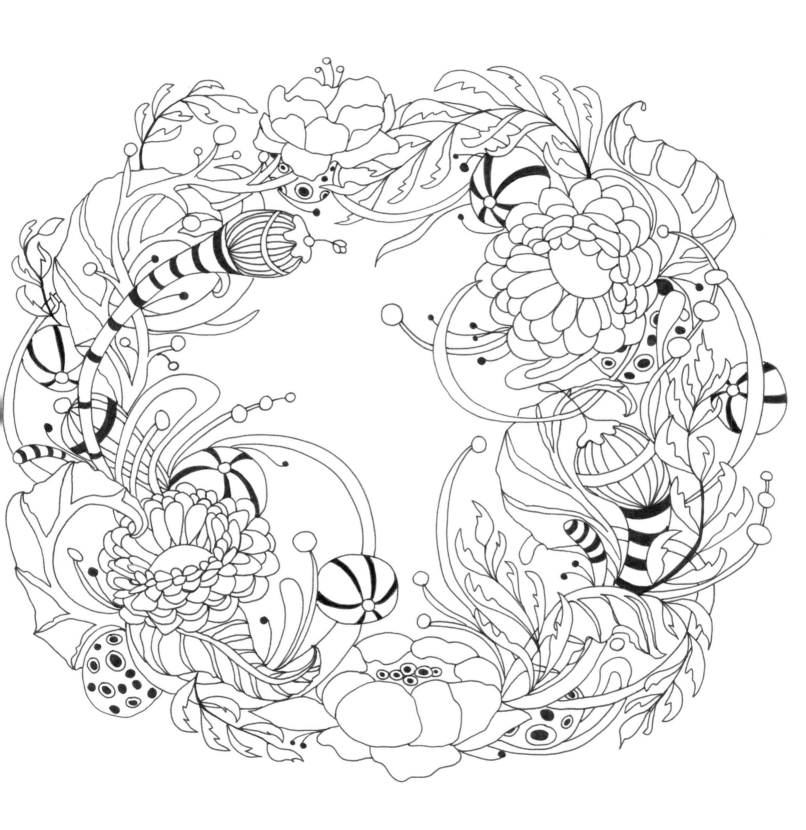

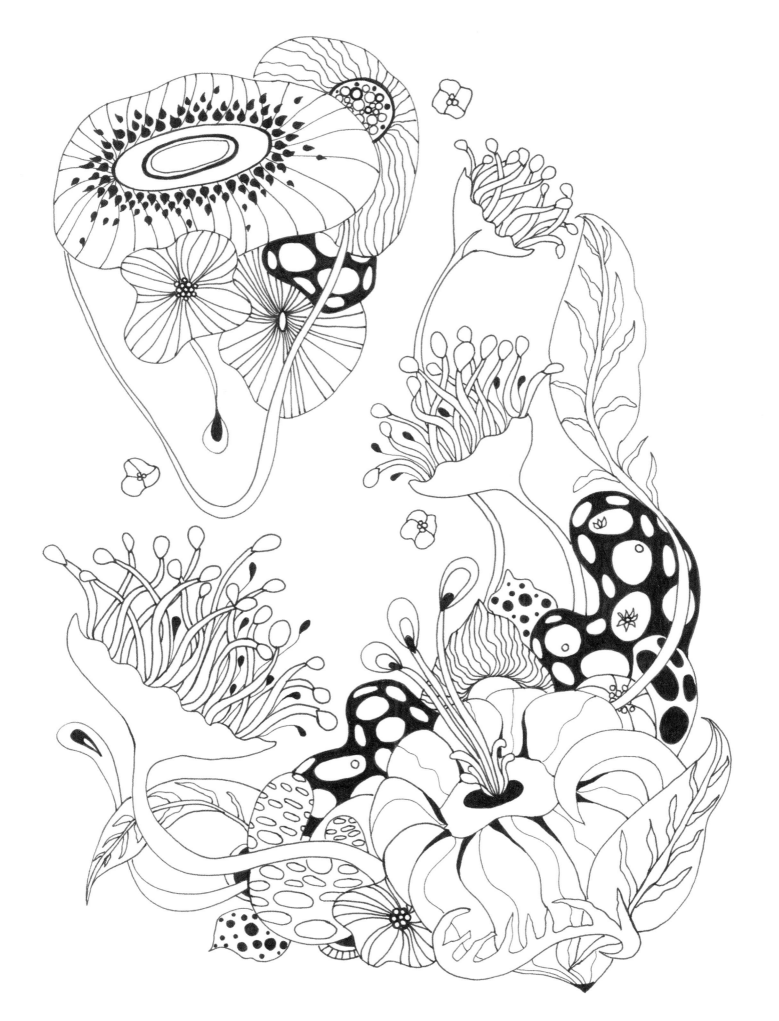

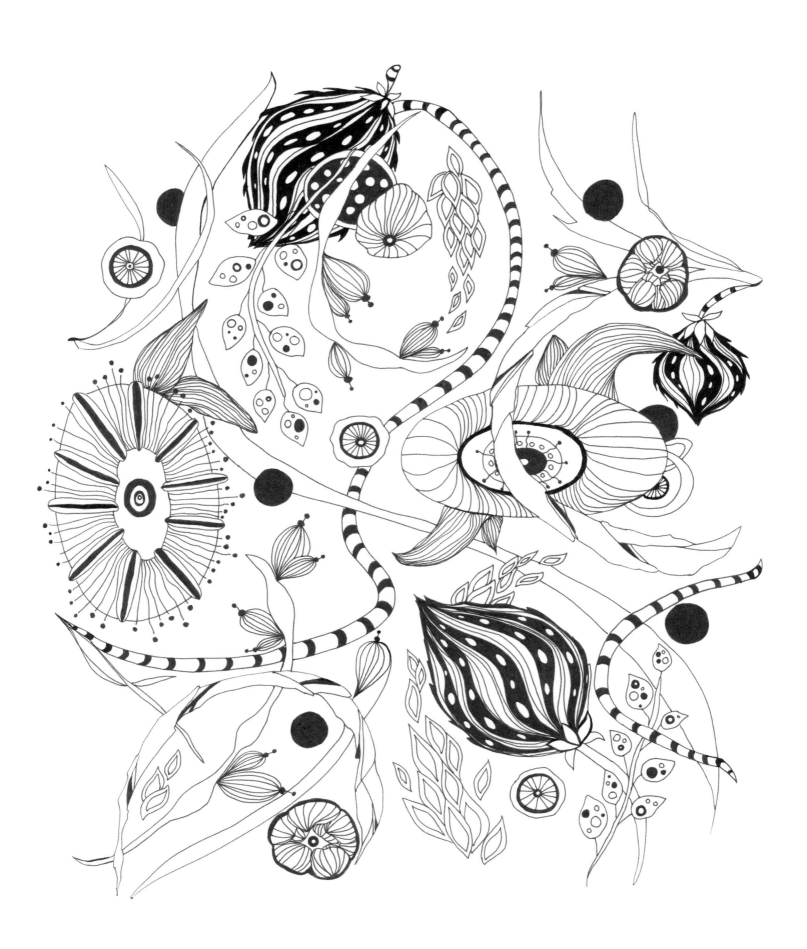

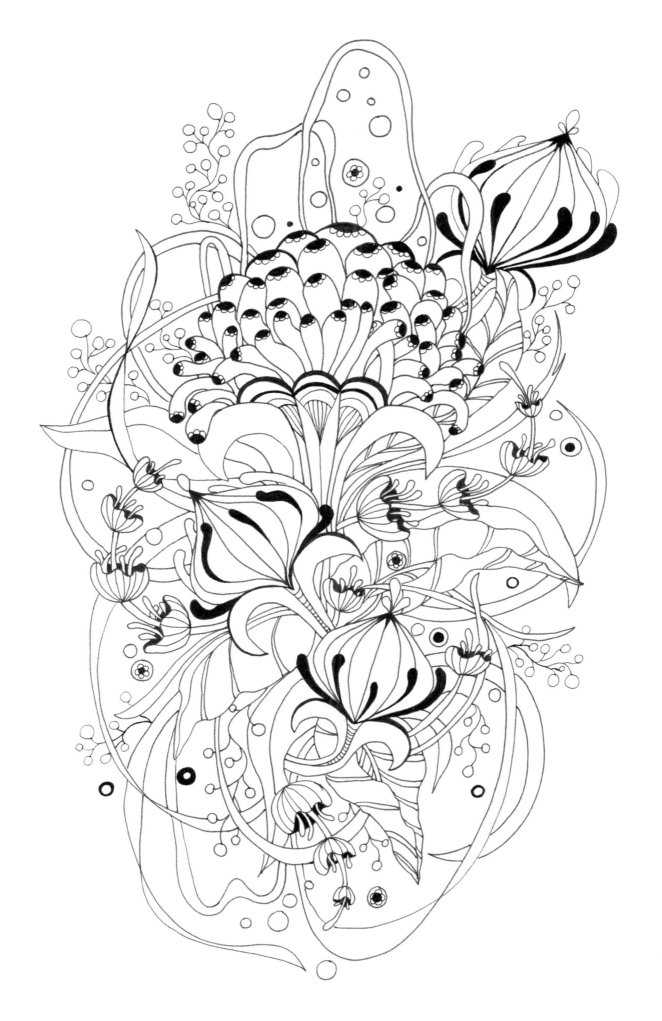

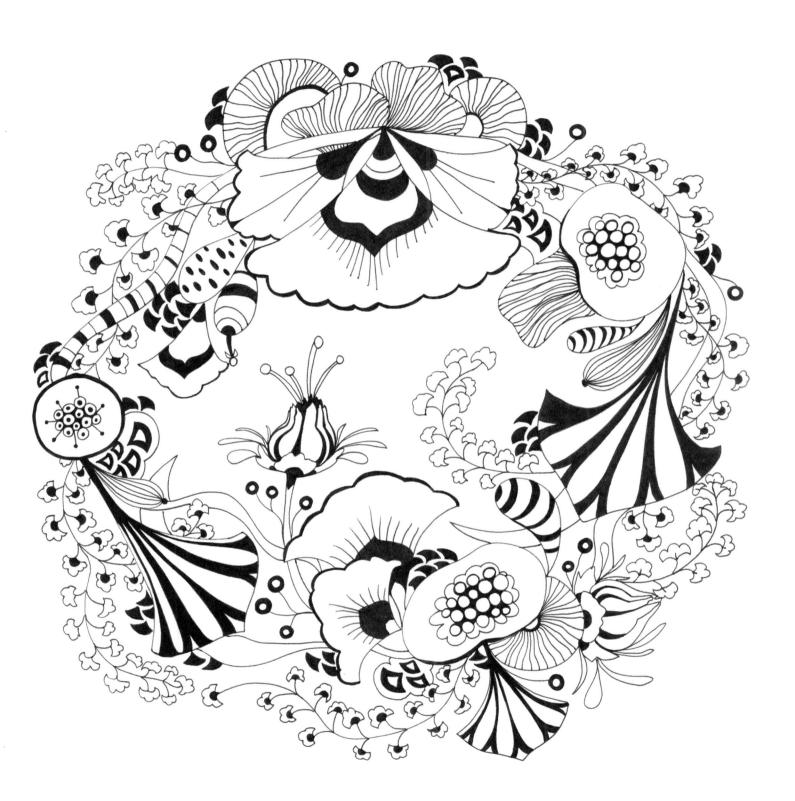

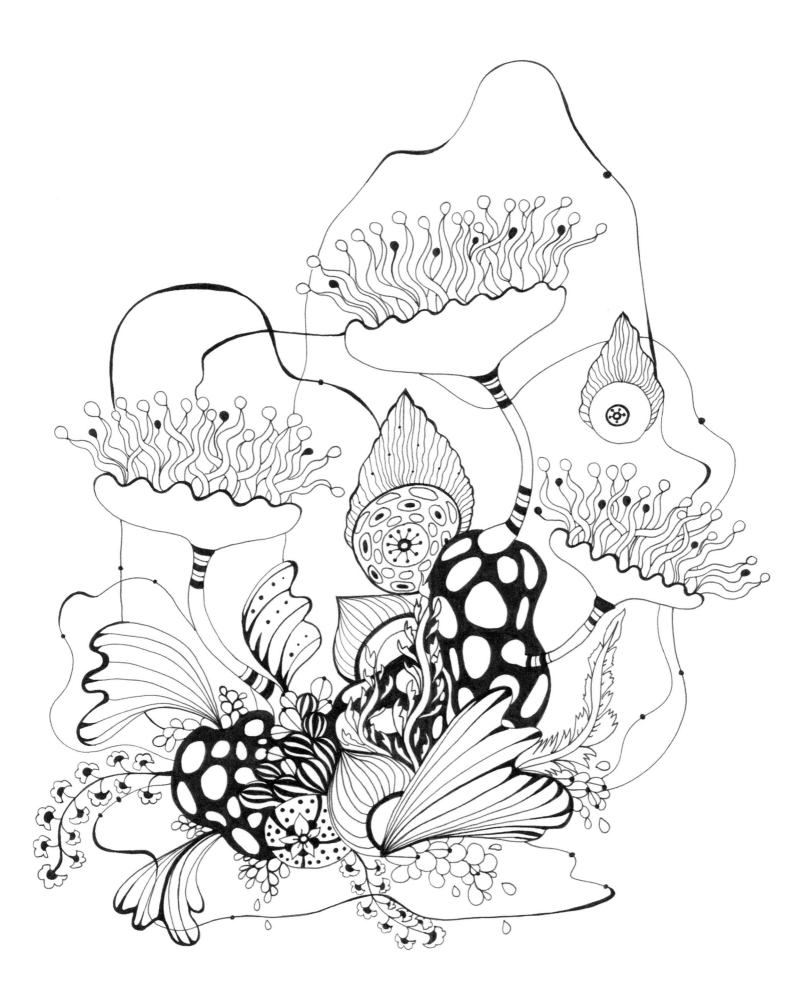

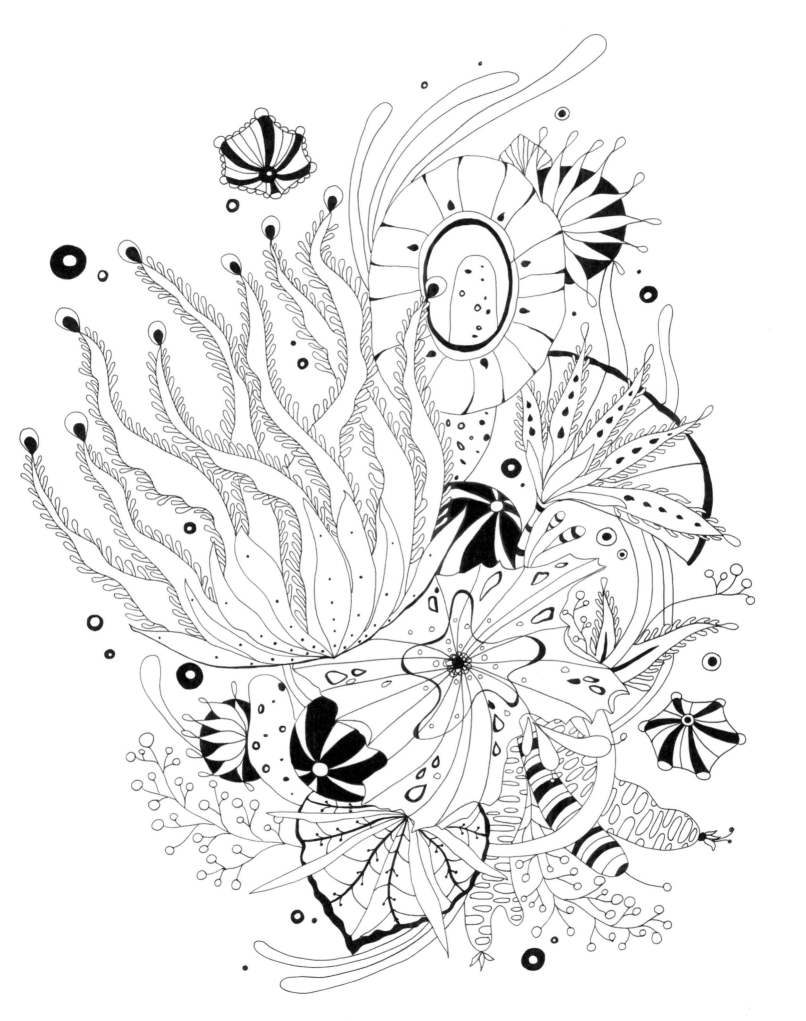

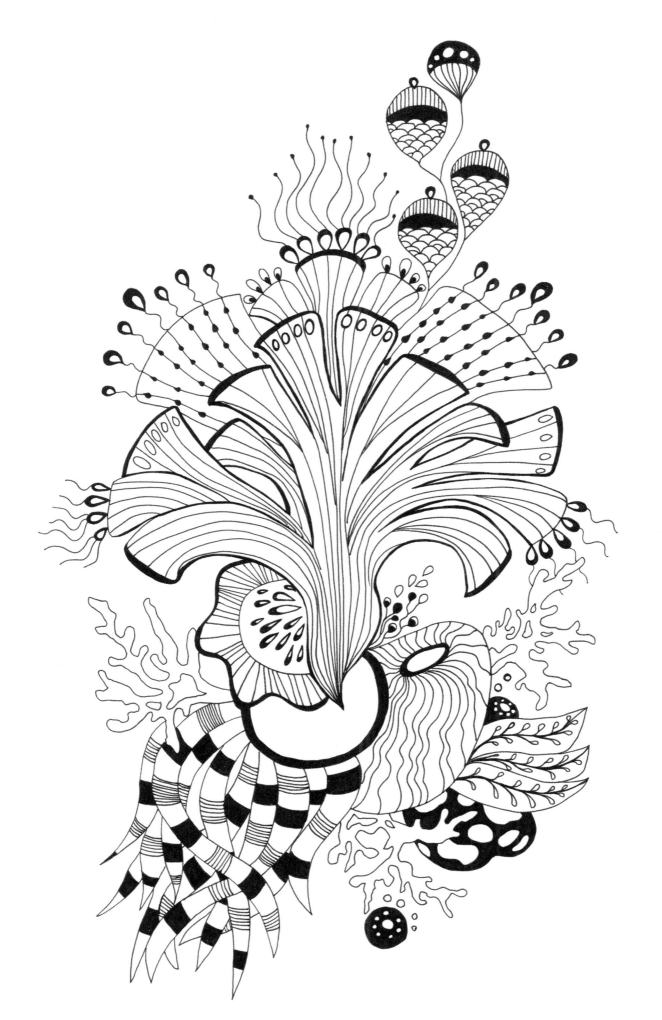

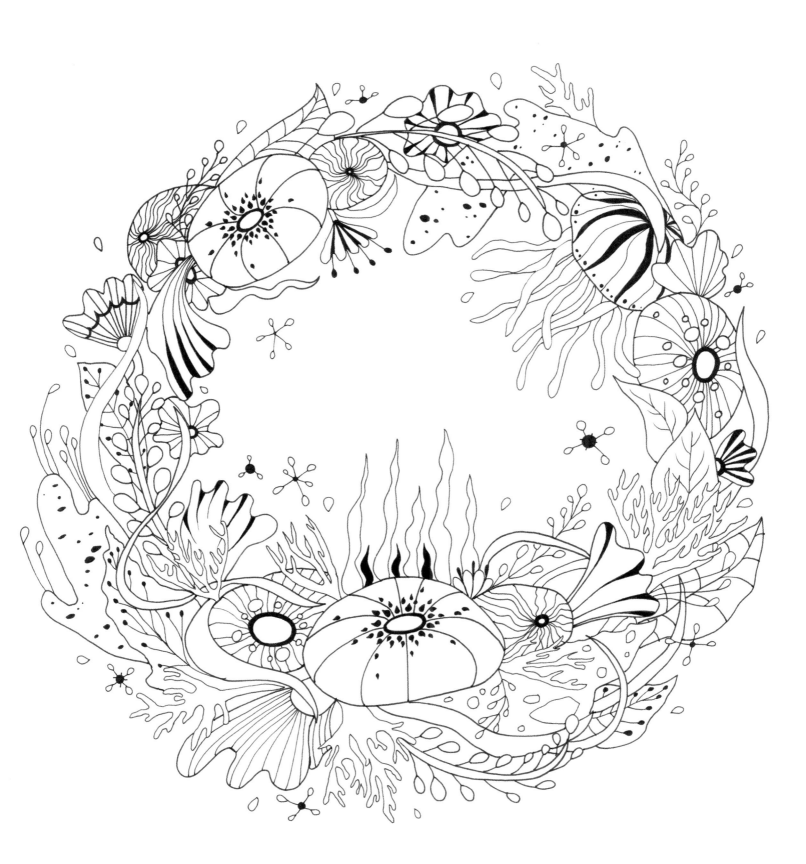

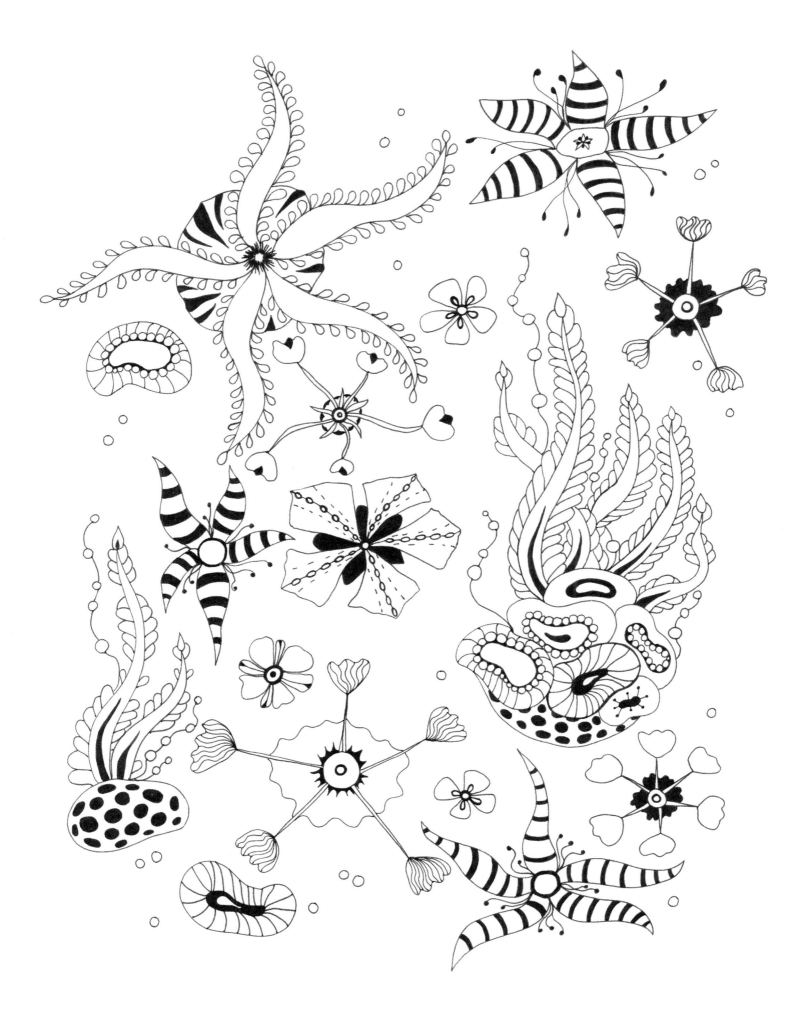

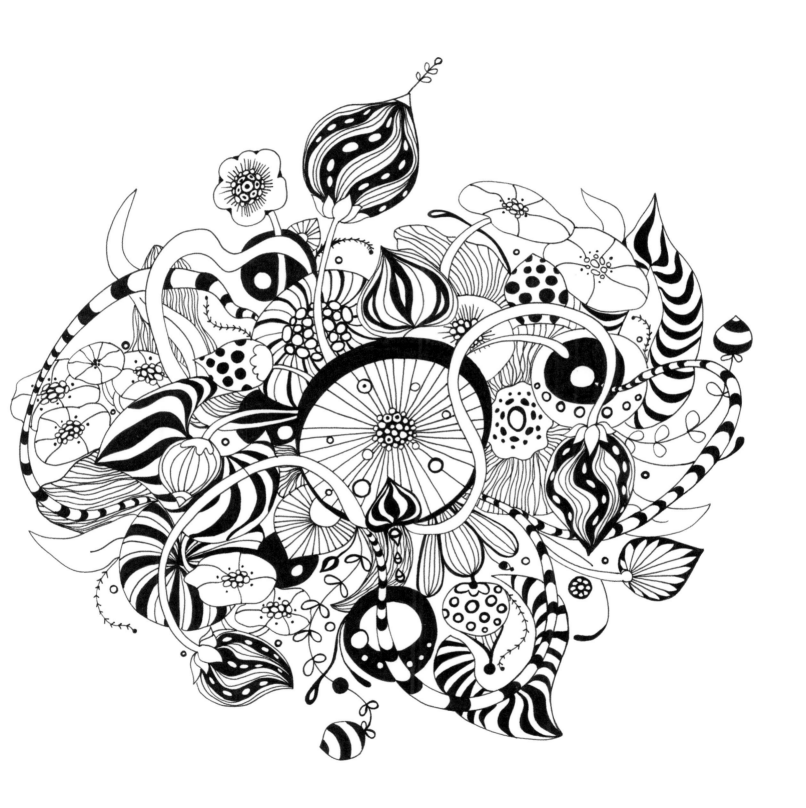

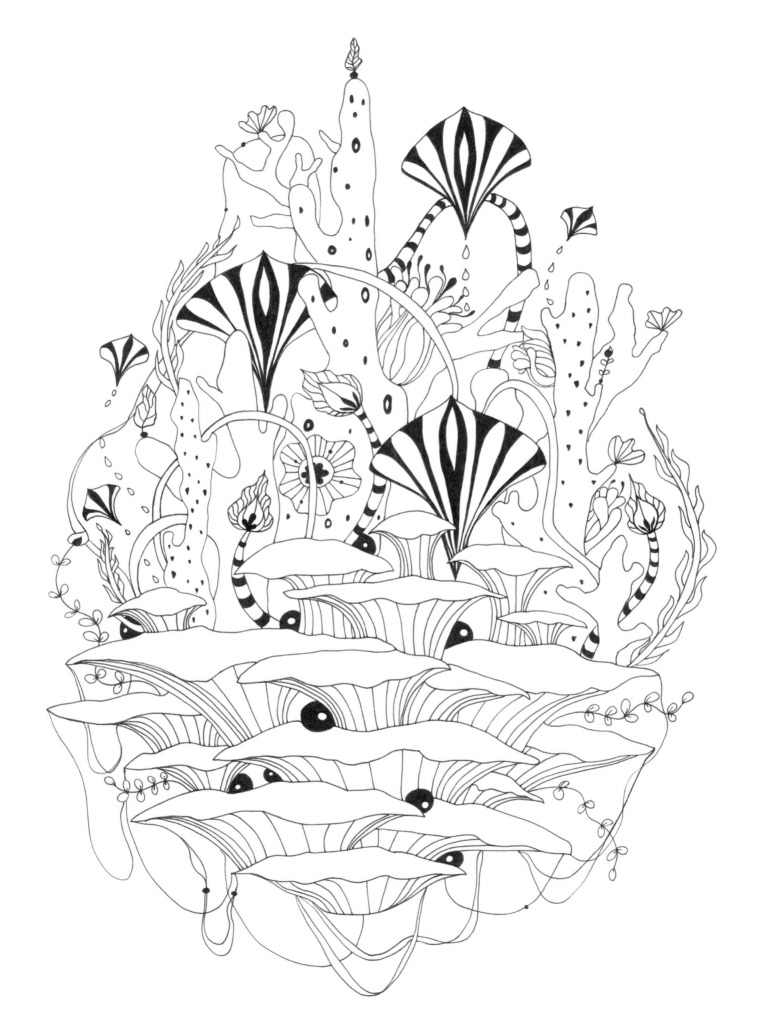

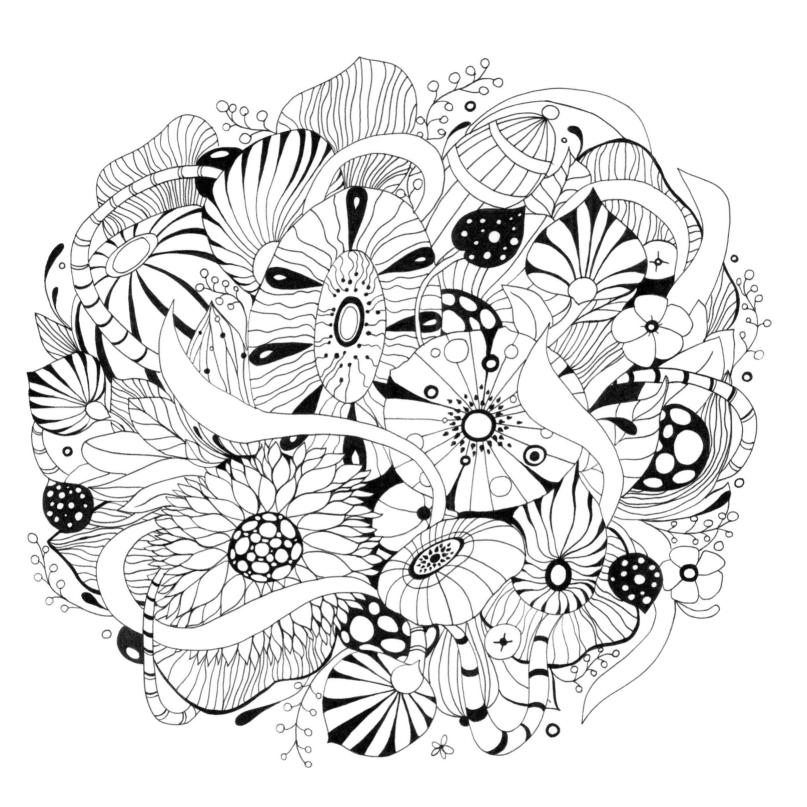

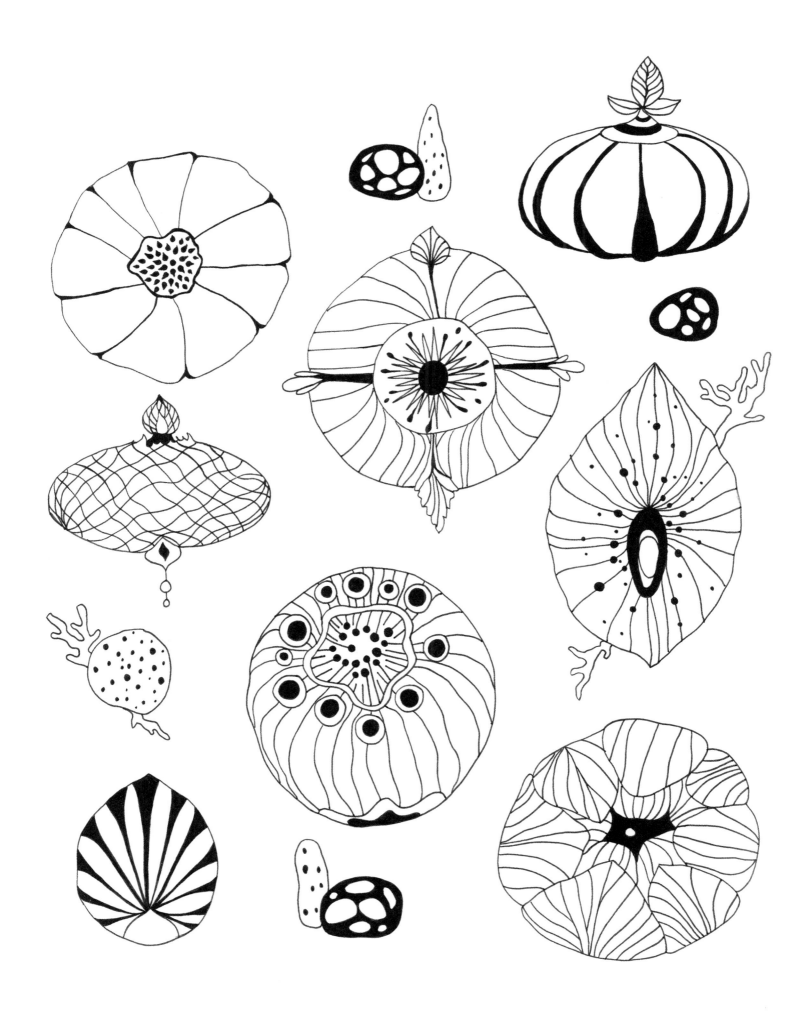

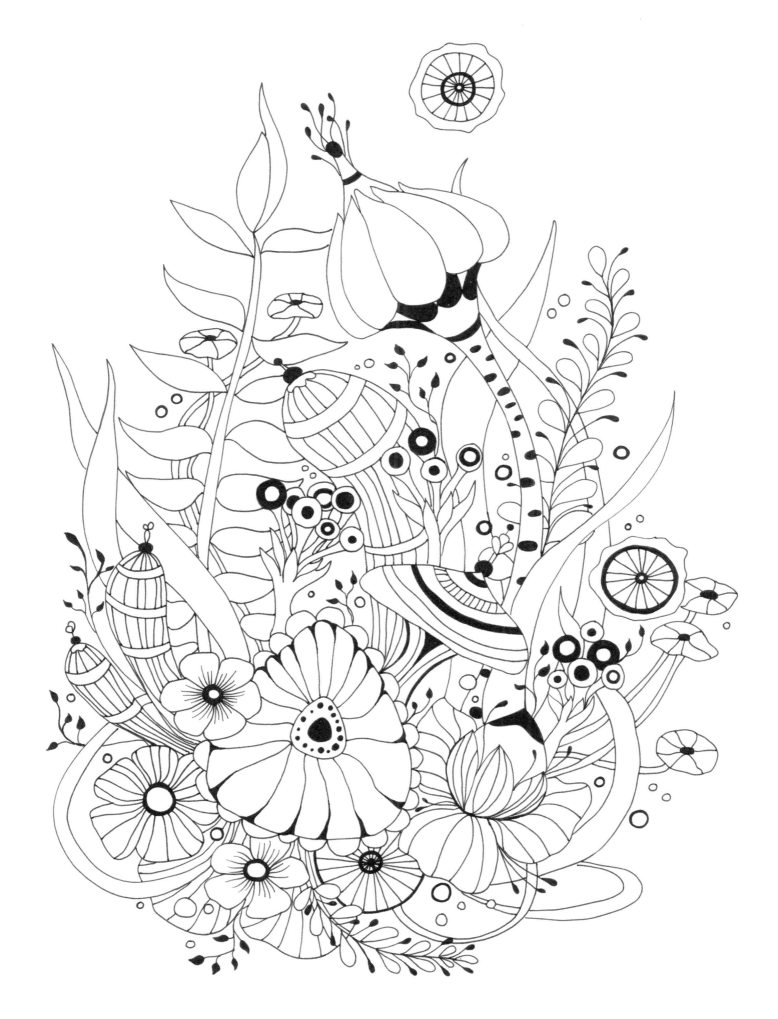

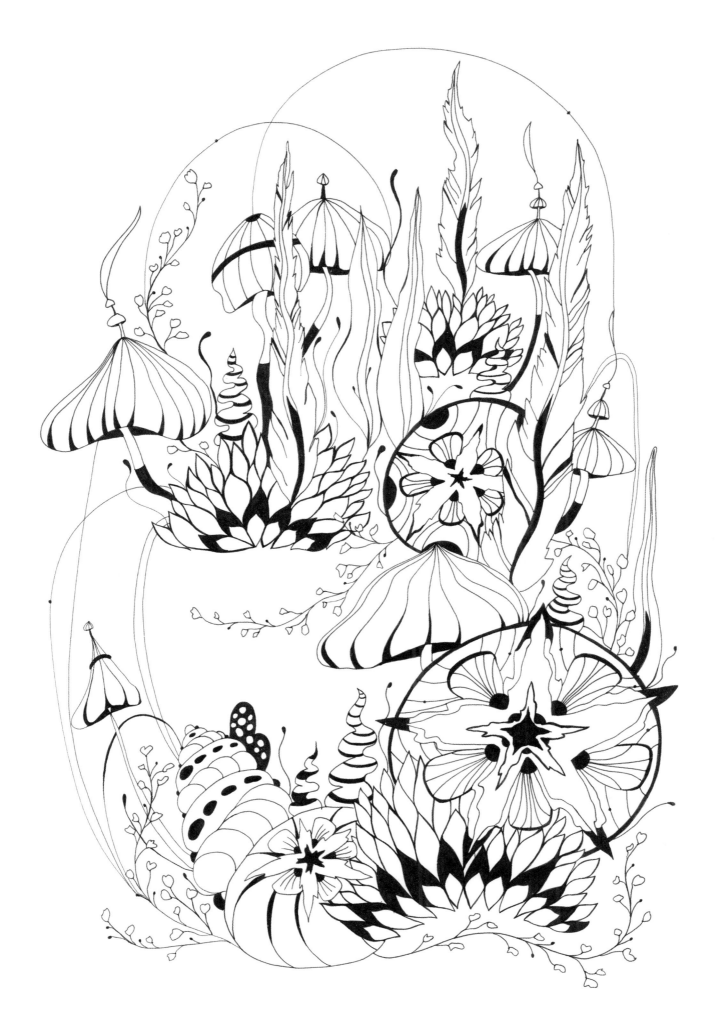

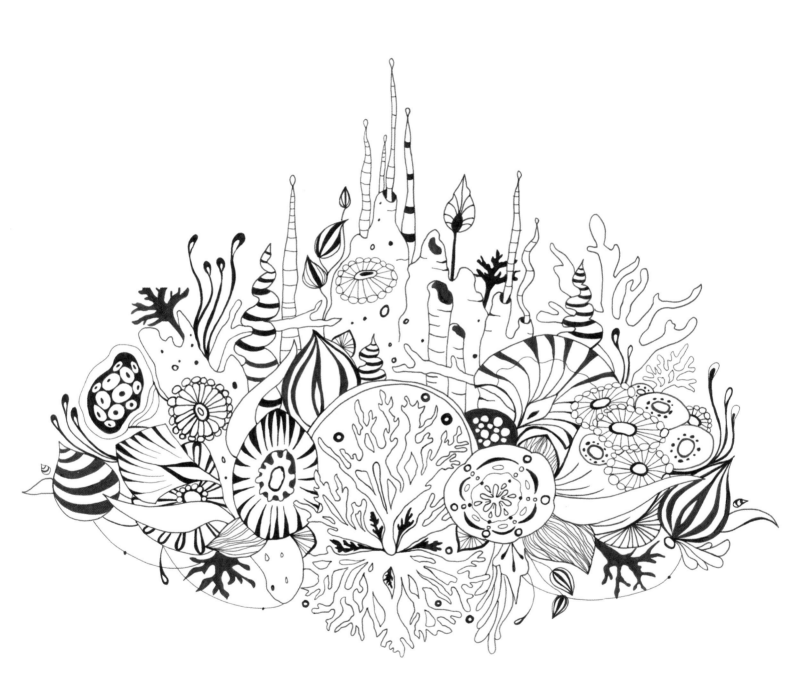

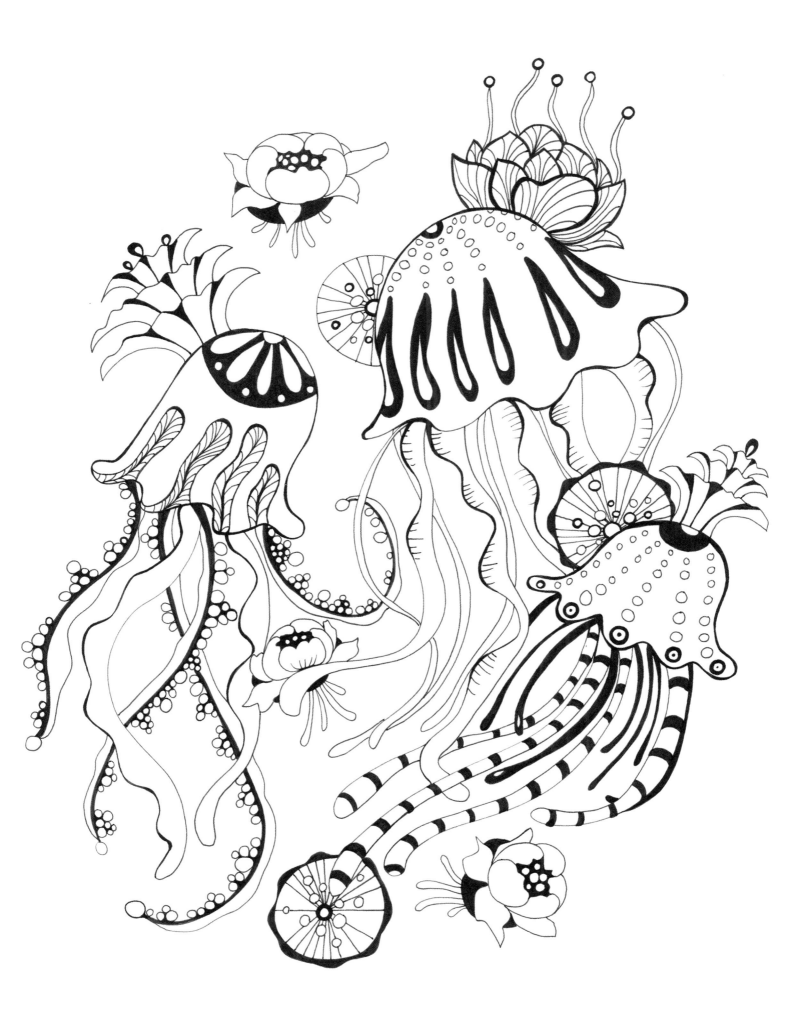

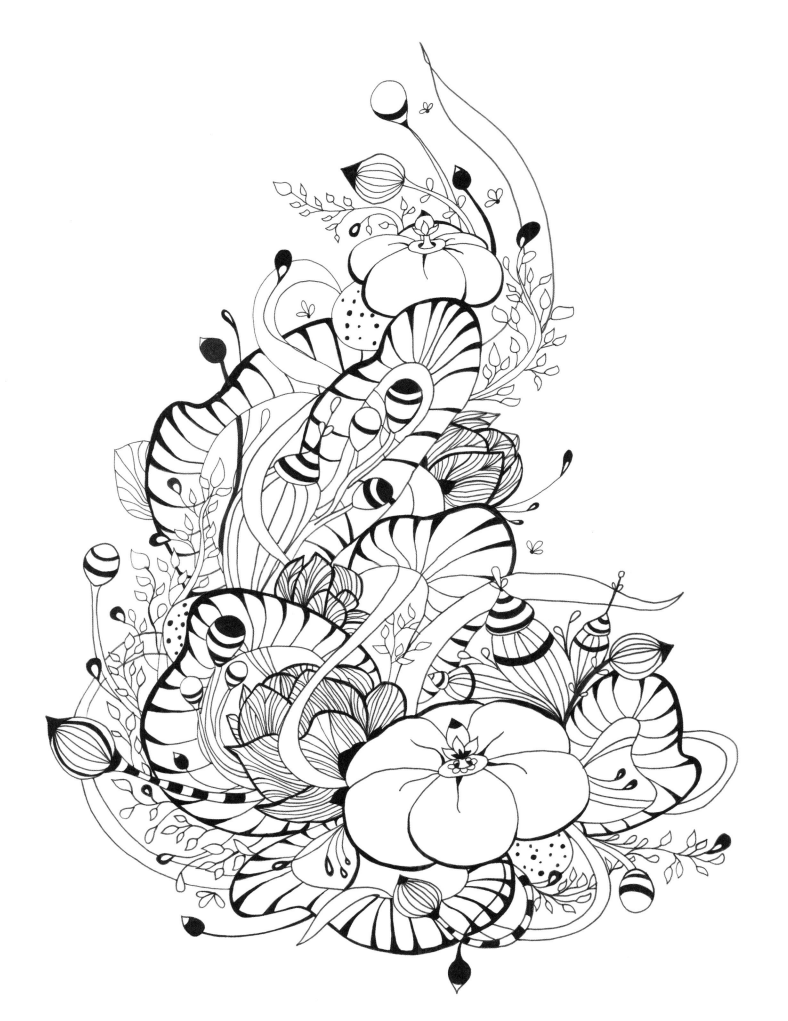

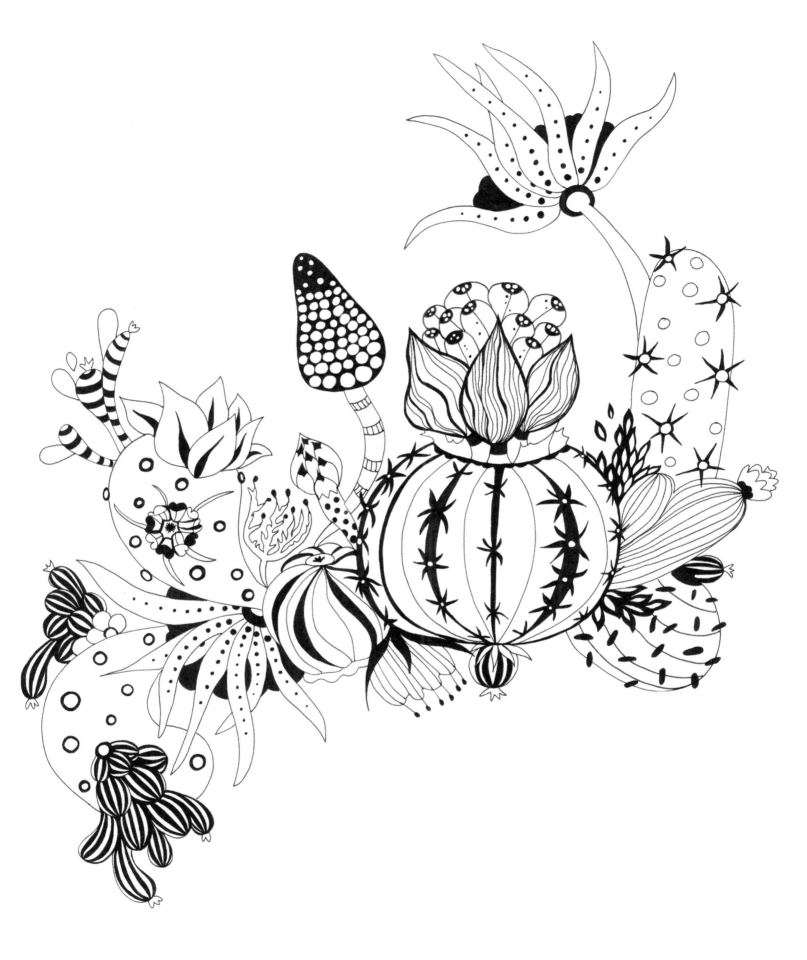

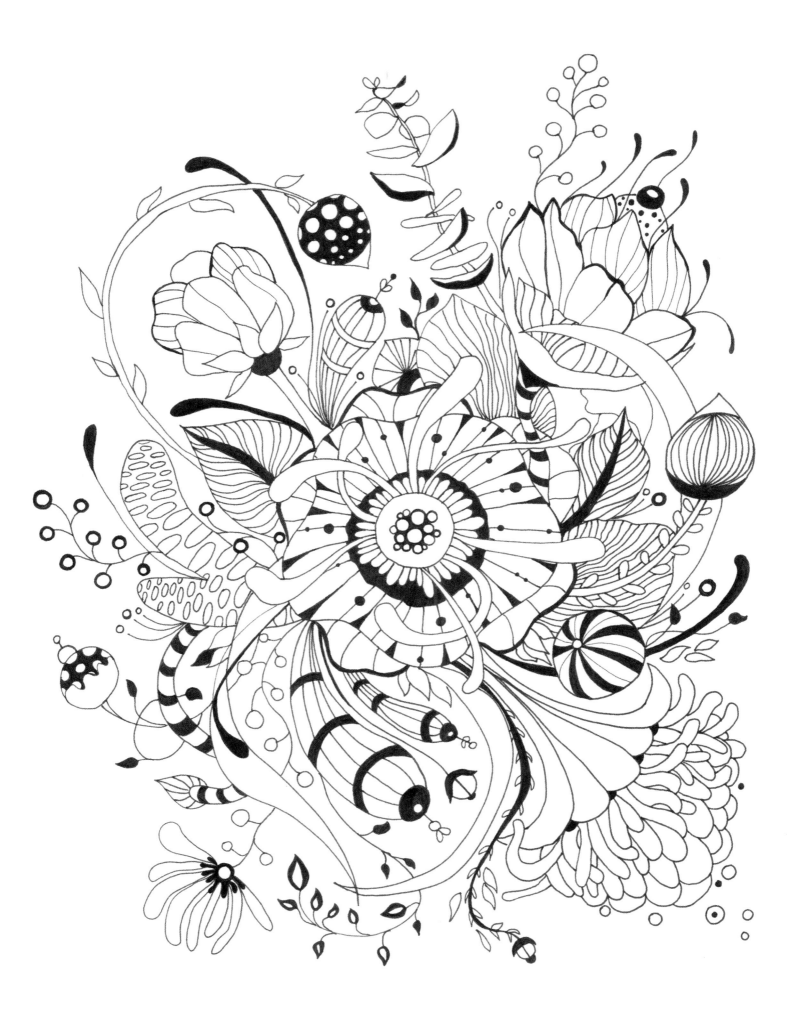

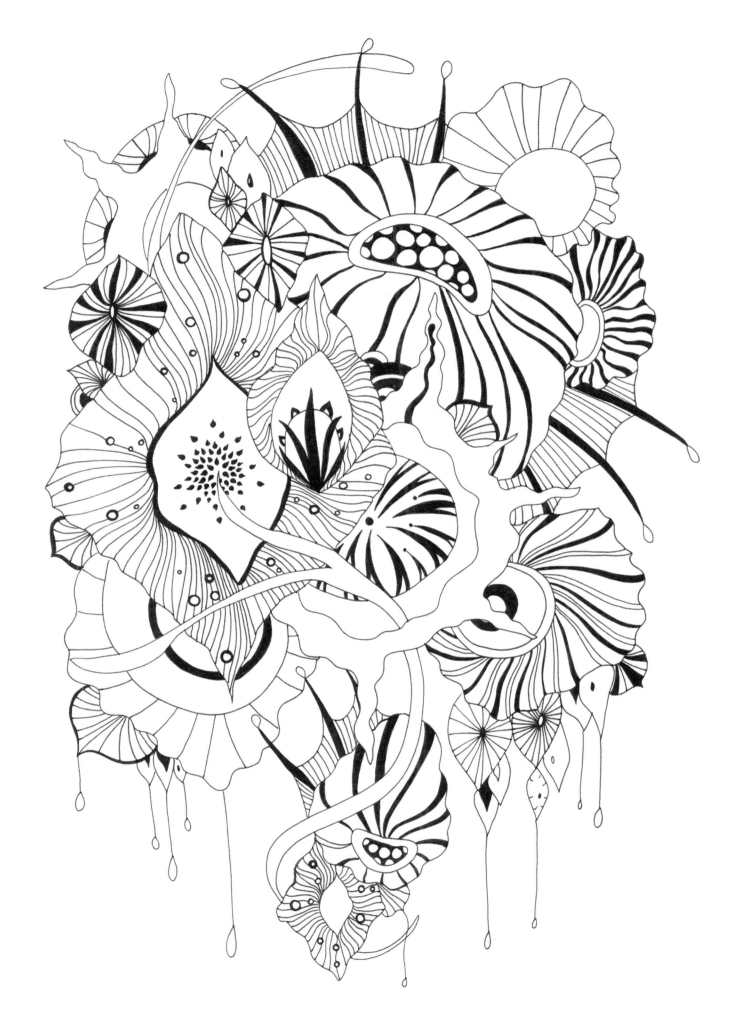

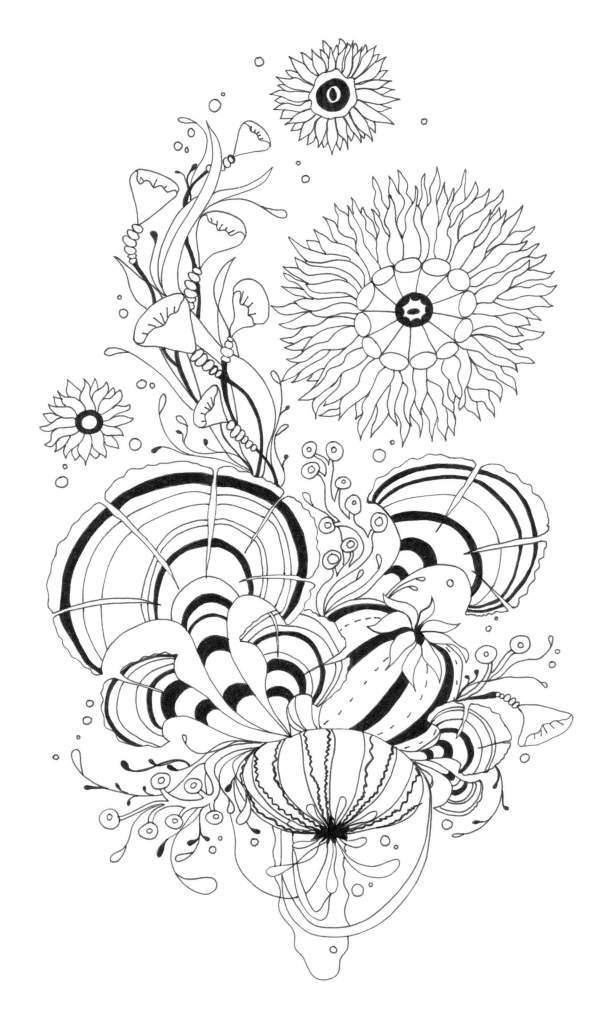

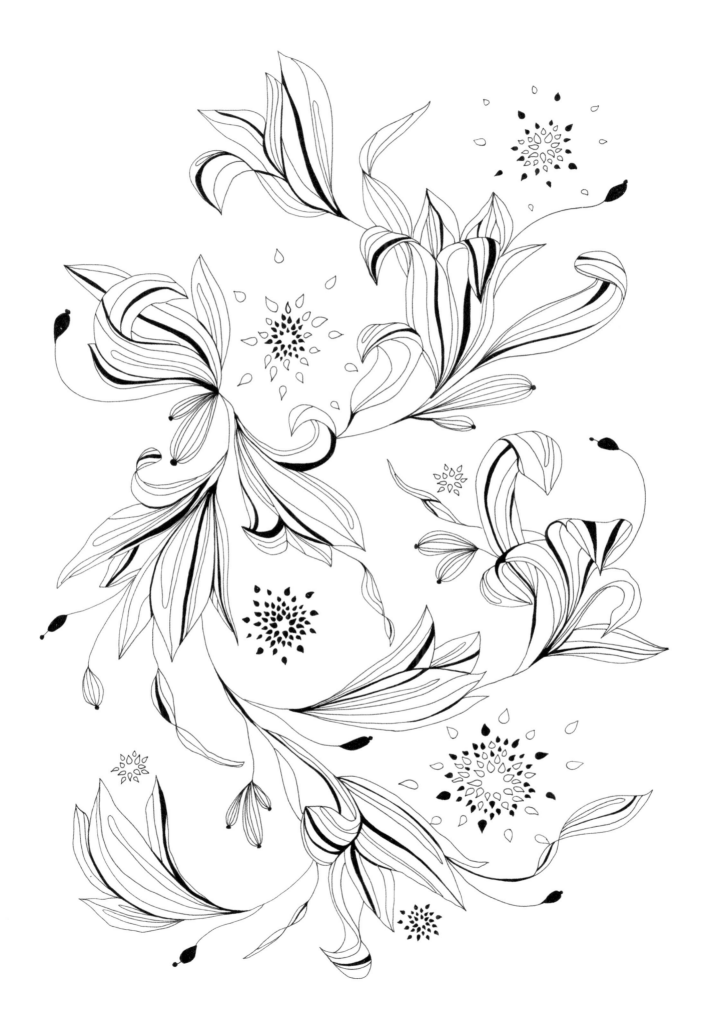

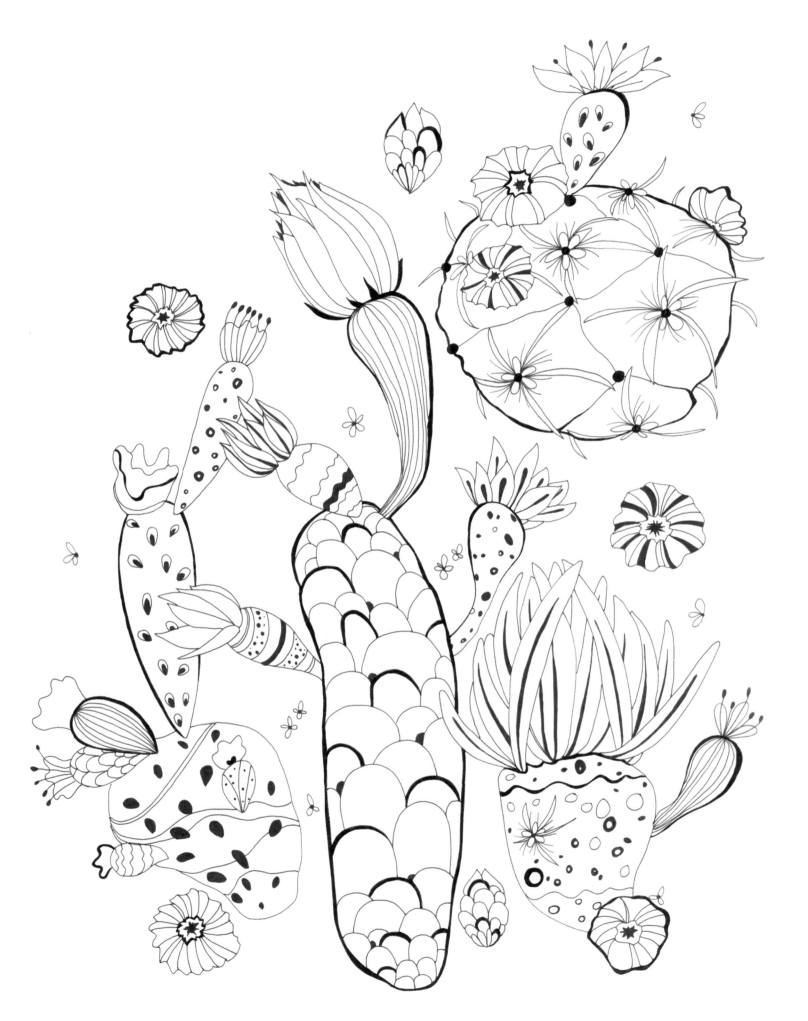

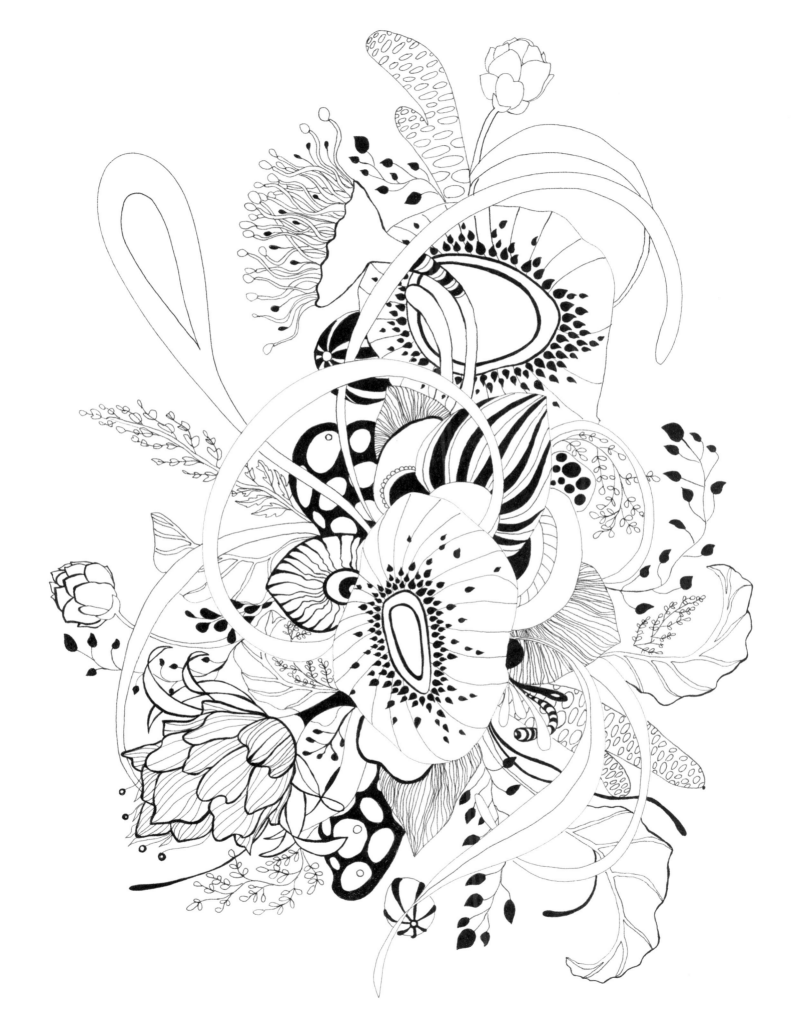

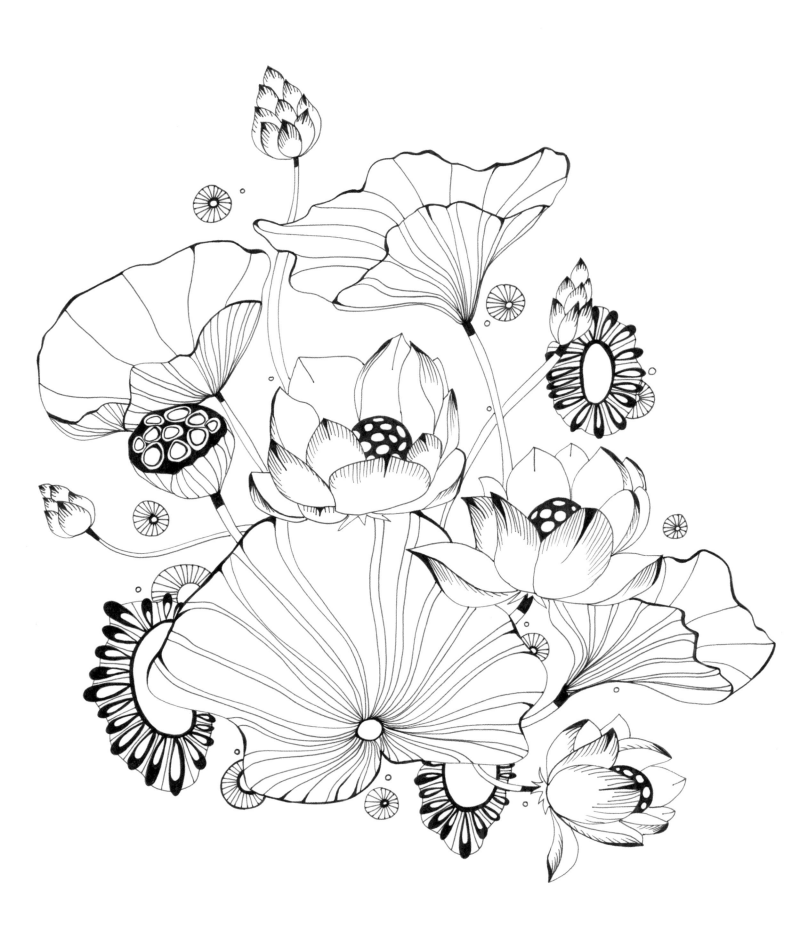

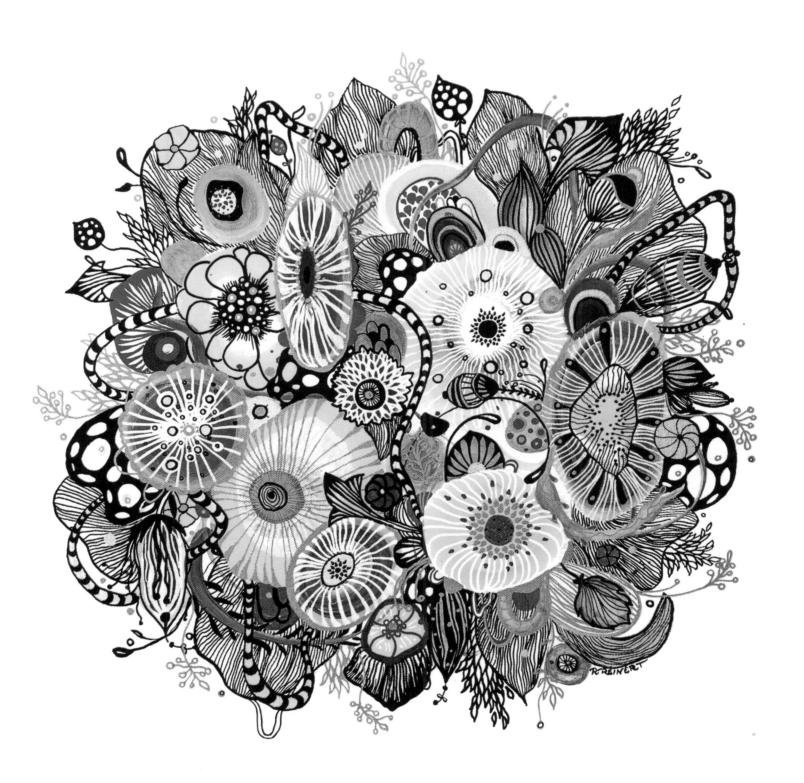

ABOUT THE AUTHOR

Since I was old enough to hold a crayon, I wanted to be an artist. I needed to create. Many children lose this dream, but at every age, that drive continued. I graduated from California State University, Fullerton as an art education major and began teaching and freelancing. I like creating and solving visual problems, and blank canvases absolutely thrill me. I've been blessed with the opportunity to paint for private collections, fashion designers, businesses, and public venues, and I've created custom pieces for loving homes. Making art is liberating, and I love pushing others to try their hand. My husband and I travel the world to find inspiration in creation, and we can't wait to see what's around the next curve.

rachelreinert.com

Get Creative 6
An imprint of Mixed Media Resources
19 West 21st Street, Suite 601, New York, NY 10010
getcreative6.com

Manufactured in China

5 7 9 10 8 6 4

First Edition